Towards Laughter

Maggi Hambling

Arts Council Funded

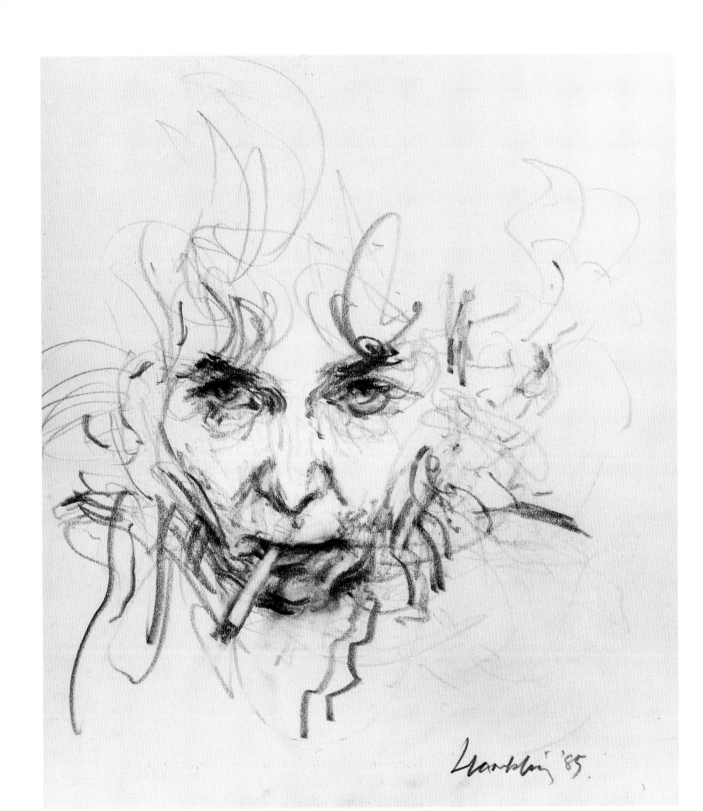

Towards Laughter
Maggi Hambling

With contributions by George Melly and Dr Judith Collins

Northern Centre for Contemporary Art, Sunderland
in association with
Lund Humphries, London

First published in Great Britain in 1993 by
Northern Centre for Contemporary Art, Sunderland
in association with
Lund Humphries Publishers Limited
Park House
1 Russell Gardens
London NW11 9NN

on the occasion of the exhibition
TOWARDS LAUGHTER: MAGGI HAMBLING
Northern Centre for Contemporary Art, Sunderland
5 October – 13 November 1993

subsequently touring in 1993-4 to
Cornerhouse, Manchester
Angel Row Gallery, Nottingham
Harris Museum and Art Gallery, Preston
Christchurch Mansion, Ipswich
Barbican Centre, London

British Library Cataloguing in Publication Data
A catalogue record of this book is available from
the British Library

ISBN 0 85331 647 3

Designed by Alan Bartram
Made and printed in Great Britain
by BAS Printers Limited
Over Wallop, Hampshire

FRONTISPIECE
plate 1 *Self-Portrait Working*
1985 graphite 29.8 × 19.7 cm

Lenders

Birmingham City Art Gallery
CCA Galleries, London
Mary Cookson
Sir Michael Culme-Seymour
Fiona Cunningham-Reid
Bernard Jacobson Gallery, London
Andrew Logan
Lady MacMillan
George Melly

Photography

Prudence Cuming Associates Ltd
David Godbold
Marcus Hansen
John Jones Ltd
Miki Slingsby

Sponsors

northern centre for
contemporary art

NORTHERN
ELECTRIC

Contents

List of Plates

Foreword

Maggi Hambling is an artist who refuses to be pigeon-holed: like all great painters, she has moved with confidence from one subject and medium to the next. She is an incisive portrait painter, skilled draughtsman, perceptive social commentator, accomplished history painter, and brilliant landscape artist. Most recently she has moved into the field of sculpture, producing a series of clay creatures which at times appear to have walked out of her paintings. Throughout these 'experiments' (as she would describe all her work), certain themes and subjects remain constant; in particular, as this exhibition sets out to show, she is preoccupied with tragedy and comedy, with tears and laughter: opposite sides of the same coin.

The laugh is unique to man as an animal, and is as distinctive and individual to each of us as a fingerprint. A laugh can be joyful, hearty and warm or bubbling and infectious; it can also be a pressure valve to allow the release of built up tension and anxiety; it can be hysterical and close to a scream; it can mask pain, fear and tragedy. A laugh can, in short, be happy or sad. The arena for exploration is vast.

In her *Laugh* paintings Hambling sets herself the problem of how to get 'inside' the laugh and paint its very essence. To reveal a sound and feeling through a silent visual format is not the easiest task, but Hambling has found successful solutions, producing the stunning group of works at the centre of this exhibition.

I should like to thank Maggi Hambling for all her work in connection with this exhibition, which has extended far beyond giving us access to her paintings and sculpture. Thanks are also due to George Melly and Dr Judith Collins who have written the text of this catalogue. Their knowledge of the public and private worlds of Maggi Hambling affords us great insight into her work. Finally I should like to thank Mary Cookson, Sir Michael Culme-Seymour, Fiona Cunningham-Reid, Andrew Logan, Lady MacMillan, George Melly, the Bernard Jacobson Gallery and the CCA Galleries, London, and Birmingham City Art Gallery, for the generous loan of works to this exhibition. Many have lent to previous exhibitions, and I am most grateful that they all agreed to be deprived of their paintings for another year. NCCA gratefully acknowledges the support of the Arts Council of Great Britain and Northern Electric for this exhibition and publication.

NIKI BRAITHWAITE
Exhibitions Officer
Northern Centre for Contemporary Art

A Love Letter to Maggi Hambling

Seeing as how this is the shorter of two contributions and the other, an interview, will cover both Maggi's life and work in chronological detail, I thought that perhaps the only way to avoid repetition was to place my friendship with her at the centre of my piece. But only at the centre. I have no intention of contributing a totally subjective portrait even if it were possible. I am, after all, a passionate enthusiast for her work, and would have been so if I had never met her. Her progress and achievement are important to me, and besides I would find it meaningless to separate her art and life.

Since I got to know her, she has trusted me enough to show me her work in progress and listen to my opinion, all of which sounds rather solemn, not to say pompous. It is neither; Maggi is serious all right but never solemn. She is certainly passionate but doesn't know how to be pompous. When we climb the stairs to her large bare attic studio we don't become two other people – artist and critic rather than Maggi and George – yet I know that the huge canvases she manhandles on and off the walls with such effortless dexterity, those watercolours, drawings, monotypes and, lately, sculptures which she lays out like a Tarot pack on the trestle table, are not just what she does, but who she is. Maggi loves fun, expeditions, drink, transvestite cabaret, laughter, gossip and parties, but always, at the top of the stairs, her daemon is waiting for her. To snare it in paint, to use brushes, rags and fingers to give it shape and force it to show its face is her mission. She was born to fight the dragon.

Leaving her in that South London attic behind that unpretentious terraced façade (the kind of house old music-hall stars retired to with their scrapbooks and threadbare finery in battered cabin trunks), I turn to our first meeting in 1980; an event of which, until she prompted me, I retained only the vaguest recollection, probably because I was, as so often at that time, rather drunk. It took place, she tells me, on a hot Sunday afternoon in a North London garden where, at a party given by an aristocratic liberal cleric and his equally 'right-on' wife, Maggi and I, both of us lying on the ground at some distance from each other and each sensing a kindred spirit, wriggled across the grass like friendly serpents. I can remember nothing of our subsequent conversation but can recall (or imagine I can recall) Maggi's hawk-like eyes mewed in by those long lashes, but this, too, may be a false memory, drawn from a later time. I do, however, retain a clear picture of our next encounter.

I am sitting in a kitchen in South London with a young art dealer and some of her women friends. It is a winter's night. There is stew, wine and firelight. Another younger woman, dressed in black leather and carrying a motor-bike helmet, enters and tells us that Maggi may drop in later. This news is greeted with rather nervous anticipation. The impression is of a visitation from some elemental figure, worshipped but held in awe. Maggi arrives. I find her not at all frightening but original and direct. She has great presence and a wonderful snorting and unrestrained laugh. I didn't connect her with the serpent in the garden the previous summer, nor with her role as the first Artist in Residence at the National Gallery in 1980, even though I had cited her, she told me later, as an example of this new tendency imported from the American campus.

The garden party, the firelit kitchen, the subject of an article; it is now obvious that chance, the devious chess-player, had opened the game by moving a few pawns around, seemingly at random. Then one day, my agent rang me up to ask if I'd be interested in chairing an art-quiz, conceived by my old friend Daniel Farson, and to be made by HTV in Bristol for Channel Four. There were two teams, with two invitees a side (artists, students, art-loving celebs), but each of them captained by a permanent contributor. One was Frank Whitford, lecturer, author and art historian, a bespectacled, moustached fountain of knowledge and a most likeable and warm man, the other (chance moves knight) Maggi Hambling. So for about a week a year, accommodated at the Bristol Holiday Inn, and recording two shows a day, I got to know, admire and love Maggi Hambling.

Gallery lasted for four seasons and was then, despite becoming increasingly popular, stopped. (Maggi and I sometimes get quite grumpy over this. We'd grown used to this annual boost to our incomes.)

Initially, however, she'd been full of doubts: TV took her away from the studio. She objected to editing. She was starting to be recognised in pubs, etc. In consequence, at the beginning of each season, although decreasingly, she would make extravagant demands, none of which were met except that she was allowed to roll and smoke her cigarettes on set.

Others also had doubts. At a party early on, a distinguished elderly painter, shaking with rage, confronted me and accused me of seducing her. 'She should be painting!' he shouted into my face. 'She's a painter!' He was right there, of course, but I don't think *Gallery* had a damaging effect on her; on the contrary, guilt, if there was any,

restored her to her studio in an even more determined state of creative determination and, in her role on the programme, she found herself having to think about and explain why this painting was supremely beautiful, that pretentious or facile. Her TV persona was a natural contrast to Frank who, although on rare occasions capable of losing his cool, was usually informative and easily didactic. Maggi, on the contrary, wreathed in permitted smoke like a small dragon, reacted entirely emotionally, eloquently or dismissively, as might be. I soon, despite the occasional surprise, anticipated her probable reaction. What she loves best of all is paint and its manipulation, not just for itself, although she likes that, too, but for its ability to trap in a near-magical manner human truth and feeling. 'Sensual', 'Sumptuous'; words like these tended to surface as high praise, and 'The paint! The paint!' became an affectionately teasing catch-phrase that we, her friends, tended to use as typifying her contribution to the programme.

Predictably, therefore, what she disliked was painstaking photographic realism, especially when used at the service of the literary or anecdotal. On *Gallery* a small detail of a painting was shown to each team in turn to see if either of them could identify the artist and, for a higher mark, the work it came from. If the detail in question was a leaf in minute detail or an eyeball reflecting a rainbow, Maggi would snort with imperious disdain, 'It's one of those Raphaelites!' As the works were chosen from British museums and galleries, and most of them, especially in the provinces, have many such pictures, she had frequent opportunities to denounce the Brotherhood and, every time I corrected her, 'It's the *Pre*-Raphaelites, Maggi', every time, with the dismissive hauteur of Alice's Red Queen, she would announce imperiously, '*I* call them Raphaelites!'

This *je m'en fous*-ism of Maggi's is something I find both endearing and admirable. The competitive side of *Gallery*, something Frank took quite seriously, didn't worry her at all. She was, for instance, hopeless at guessing the painters from the small details, something that Frank excelled at, but even when it transpired that the whole picture was one she knew well and loved more, it never threw her for an instant. She presented, of course, a memorable figure on the box, not only because of her personality and unique delivery, but equally on account of the way she dressed, or at least cross-dressed. Maggi away from Clapham tends to wear men's clothes: evening dress, blazers, bow ties, etc. She doesn't look like a man, though, she looks like an Edwardian music-hall male impersonator; one of those attractive androgynous creatures ('Burlington Bertie' or

'Gilbert the Filbert') lighting a cigar or removing their gloves with studied nonchalance, and this theatricality, very much a part of her, does indeed give some weight to the angry accusations of the elderly painter at the party. Not much, though, for while Maggi will freely admit that *if she had not been a painter* she would have been tempted by the stage, and while her private late-night cabaret improvisations can be brilliant, it is still very much a case of Ingres' violin. Maggi in paint-smeared jeans and shirt is doing what she must, although of course her love and understanding of the performer and the comedian, and especially the ambivalent phenomenon of the laughter they provoke, is an important element throughout.

This paradox is personified in the uneasy reaction provoked by her double-headed joke on the last series of *Gallery*. Just when we were due to record, she took her place on the set dressed, as usual, as a knut or masher, but wearing this time a very realistic moustache. The director was not best pleased and asked me, through my connecting earpiece, to enquire why. Maggi's reply was 'to keep my end up', and it was only then I recognised that *her* moustache was an exact replica of that sported by her rival team leader, Frank Whitford. With some persuasion, the director agreed that she should keep it on, but what was strange is, that when the programme was transmitted, after the initial shock had worn off, you forgot it was there. Not so when, on a later programme, she appeared in a low-cut, gold lamé evening dress and Joan Collins make-up. That was somehow really shocking but of course it seemed like a conciliatory gesture.

Before leaving the public Maggi, I felt I should touch briefly, and after consulting her, on her sexual orientation. Is she gay? Obviously. Does she proselytise? Is her work at the service of Gay Lib? No and No. She is and has always been 'out' but, while celebrating and exploiting the insights she derives from her sexual double-sight (an advantage she believes everyone could make use of if they were less inhibited) she doesn't insist that homosexuality is *superior*. On the feminist front, too, she refuses to appear in mixed shows limited to women painters. She is, she maintains, an artist; not a woman artist nor a Lesbian artist, but an artist! Nevertheless, the powerful thread of sexuality which runs through her work is, I believe, predominantly (although not exclusively) masculine. I have always felt that in her most overtly sexual painting, *Pasiphae and the Bull* (*Conception of the Minotaur*), 1987, Maggi identifies herself with the tender but aroused animal, rather than the provocative girl carelessly dis-

guised as a heifer; but I have never asked her and, if wrong, apologise.

During the several years we met in Bristol, Maggi and I became firm friends and I started to see her regularly in London. Every Christmas she would book a front table and bring a party of friends to hear me at Ronnie Scott's, and we would sometimes visit other entertainments together such as the spectacular drag review at Soho's 'Madam JoJo's' with its grotesquely wonderful star 'Ruby Venezuela'. But our friendship involves far more than fun. When I was in a real muddle and turned to her for advice, I discovered that not only was she prepared to level with me, not only was she completely *au fait* with *why* I was so upset, she was also determined that I should recognise that whatever choice I made had to be mine; a rare virtue in confidantes, most of whom cannot resist the temptation for manipulation in exchange for their gin and sympathy. Nor did she 'take sides', another admirable and far from universal response to a cry for comfort. Maggi Hambling, like her work, offers tough love.

For quite a long time after we'd met, I knew little about Maggi's background, apprenticeship, the art-schools she'd attended, that unlikely sabbatical (1967-9) when she renounced painting and drawing in favour of conceptualism and street happenings, her ecstatic and addictive return to paint, the early work of her maturity. Since then I've heard about most of it, either in dribs and drabs from Maggi (she is more alive to the present than the past) or in articles and catalogue introductions.

 As for the earlier work itself, those eclectic but restlessly inquisitive pictures of the 1970s, here, too, I have seen few originals and know how deceptive reproductions can be, but have always been struck by how many of her later themes declare themselves in retrospect. It seems to me, however, that around 1977 she began to be certain of her way and by the 1980s (more or less at the time she was appointed Artist in Residence at the National Gallery) she set off boldly on her journey.

 There is always a moment in a true artist's career when 'Who's that by?' is replaced by 'Isn't that by ...?' In Maggi's case it was the series of paintings of the old comedian Max Wall which coincided with that moment, and it was not long after their completion that we became friends.

 It was always obvious why these images of the rather bitter and lonely old man re-emerging from obscurity to become the darling of the intellectuals should have touched a public nerve, and it had, as is usual, very little to do with art. In painting him, Maggi, as so often, courted the banal, flirted with the cliché, and somehow just avoided their embrace. The tragic clown, the tears behind the mask, the loneliness when the audience has gone, have tempted many artists and most of them, even the greatest, have stumbled and fallen. Maggi herself stumbled a little here, but recovered her balance every time, and I suspect (without confirmation) that it is because, while Max was quite prepared to play Pagliacci, Maggi wouldn't buy it. Like most great comics, he wasn't all that likeable, and self-pity is not very attractive. Maggi's Max Wall, poised half-way between realism (the full ash-tray) and surrealism (the comedian's shadow becomes that of his alter-ego, the grotesque Professor Wallofski), is a complex creation. It is part homage to a genius, part an honest yet unmalicious portrait of a man who had so often queered his own pitch; one of those whom Auden described as 'battered like pebbles into fortuitous shapes'. Indeed such figures, such 'pebbles', were to remain part of her subject-matter for most of the 1980s: the Clapham lady compulsively shouting at a car, the collapsed derelict on the pavement, the conjuror in the hideous South London pub pathetically failing to divert the raffish or shabby punters. Her paint at this time was applied in short rapid strokes or dabs 'corrected' by straight lines in perspective: the geometry of the car the lady is cursing, the paving stones on which the tramp lies dead or unconscious. Something here reminds me of those 'cages' by which Francis Bacon prevents his ectoplasmic phantoms from escaping, but Maggi's creatures are particularised, living in a given place at a set time, but all hovering on the edge of madness.

 In her recent work Maggi has abandoned this handwriting in favour of much bolder calligraphy. She has retained it only for her commissioned portraits, which ensure her a certain security yet remain honourable pictures. The difference, however, is that the colour, drab in the case of the malcontents, glows and shimmers and especially in relation to what her subjects are wearing. Their tweed and wool reminds me of the description of his corduroys by Huxley hallucinating on mescalin at the Gates of Perception.

On 17 October 1987, at the Serpentine Gallery, I had my first opportunity to visit a retrospective of Maggi's work. She seems to have a gremlin who arranges her openings. One coincided with the collapse of the economy, another with the departure of the critics to the Venice Biennale,

and this one took place the evening after the great hurricane. As Hyde Park was especially badly hit, to gain access to the gallery required some mountaineering skills, but it was a glittering evening and a very convincing one, too. A well-judged sample of the earliest work set the scene, but the majority came from 1984-7 and were a revelation.

'She's always been able to draw,' said David Sylvester as we left. 'Now she is beginning, only beginning, to learn how to paint.' I found this judgement over-severe at the time. Her work since confirms it. Towards the end of that show a great, rather than a promising artist was emerging like a dragonfly from its imago.

In 1985, towards the end of the 'dispossessed' series, Maggi began to paint large pictures of the bullfight; yet another example of her *chutzpah* when it comes to taking on subject-matter you might imagine totally exhausted. In the event, they are convincing, tragic, repellent and grand. While acknowledging bullfighting to be an art rather than a sport, she is nevertheless repelled by its cruelty. Her black bulls, solid as rocks, die, become meat, are dragged ignominiously off. The surrounding blur of the matadors, the crowd, the sand, seems in frivolous contrast to this blood-bolted darkness at noon. Her image, both as a drawing and a painting, of the bull's head collapsing in superimposed stages, is a wonderful picture, and the mythic basis of the Corrida (why do people think ancient mythology justifies contemporary cruelty?) led her to invent two other memorable images: the bestial conception of the Minotaur and the creature itself disturbed while eating human flesh. Even so, the bull series was complete in itself and, together with Maggi's dog Percy leaping into the air, mark the end of her 'realism', at any rate for the time being, and only as a painter – she draws from the model obsessively as she always has. None the less, it was on this show that the 'sun' first rose. In July 1985, while staying on the Orwell Estuary in Suffolk, Maggi had taken to getting up very early to execute a series of watercolours of the dawn, of necessity at breakneck speed, and these were joined later by sunsets painted mostly in West Wales. These sketches give the impression of works of record. Back in the studio they were transformed into large oils veering towards the abstract, painted with a heady new freedom, reliant on chance and delirious in colour. With these paintings Maggi truly came of age.

In 1988 her mother died and Maggi drew her on her death-bed; a moving and, I feel, appropriate thing to do. Maggi has always, some might think surprisingly, got on well with both her parents and is very fond of her father's late flowering as a painter, but her mother's death caused her to mourn long and deeply. It affected her art, too. In that same year she painted *Drowning Sunset* (cat.10), a large oil, which I bought from her and from which I derive true and continuous pleasure. In it, as I have written elsewhere, 'the sun slides down its own vertebrae to extinguish itself in the dark sea'. It is a wonderful image of the inevitability of death and how to accept or even celebrate it.

In 1989-90 the crescent moon (a feminine symbol) joined the sun, but the moon was often snapped in two and drowned in pigment, overshadowed by nocturnal events, huge lovers copulating amidst clouds, for instance. In August 1990 Maggi dreamt she drowned in mud but accepted it. She painted several moonscapes following this powerful vision and then, in 1990, began the series of *Laughs* which have given this exhibition its picaresque title. The laughs, I imagine, signal the end of mourning, but we are a long way from bulls and leaping dogs. Laughter, an activity unique to humanity, is not always innocent or happy (as a child I was perplexed as to why witches and villains laughed so much). Maggi's *Laugh* pictures, whether in oil or watercolour and ink, are not at all reassuring – far from it. Amongst many other *Laughs* there are those at Christmas, in Spain, while dancing, at Avebury [plate 15], laughs fruity, hairy, in prison, in the brothel [plate 37], over a city at night, executed by a bishop, at All Souls', Oxford [plate 32], on a mountain, in an armchair, and at the point of suicide [plate 41].

The *Laughs* are both abstract and concrete, but always physical. They are sometimes witty, sometimes tragic, but always serious. Maggi has pursued the laugh as Bacon hunted the scream. She, like him, exploits chance and welcomes it, but unlike him she moves in on the laugh, so close as to remove any items of reference beyond a suggestion of fishnet stockings (*Brothel Laugh*) or thin streaks of blood (*Suicide Laugh*). These are extraordinary and unique images. She knew when they didn't work (she destroyed many) but those she passed, whether on paper or canvas, will come to be seen, and I am quite convinced of it, as amongst the great images of our time.

GEORGE MELLY
July 1993

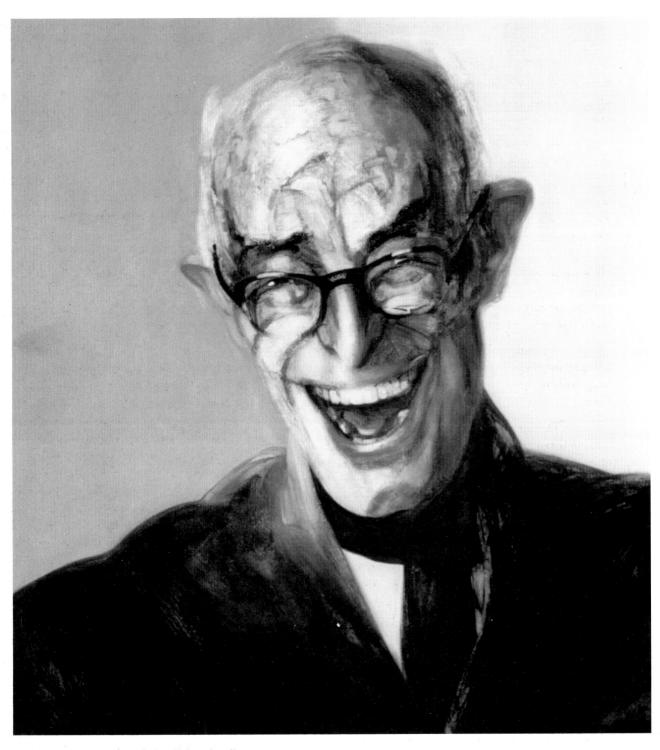

2 *Lett Laughing* 1975-6 oil 71 × 64.8 cm (cat.2)

Maggi Hambling in Conversation with Judith Collins

JC *Why have you chosen to title this show 'Towards Laughter'?*

MH The word 'towards' implies a journey, and throughout my life the work has reflected the journey of my life, I mean the very obvious journey from birth to death.

In this journey laughter has been a constant thread. Do you know why?

The border line between what is tragic and what is comic interests me. I believe there *are* people who go through life without laughing but I don't see how I could. The exhibition begins with the painting of a clown called *Mask* [plate 22], done in 1972. After four years of making audio-visual and conceptual work, where I was the impresario of my idea rather than the executor of it, I realised the only thing I could do myself from start to finish was to make a canvas and put some paint on it.

You have said to me that the subject of laughter is important to you because it has a dark, shadow side. So laughter and sorrow, comedy and tragedy, are the same bundle of things?

They are a pathetic human way of trying to come to terms with the fact of our own death, the fact of other people's deaths, the fact of the horror we see on the news every day, the terrible things that happen. Some moments you cry, other moments you laugh.

Don't you think it's both brave and challenging that you've chosen this subject for most of your work?

I wouldn't say most of my work, but comic paintings or humorous paintings, paintings that other people anyway find humorous, have often cropped up. I took on the subject of the laugh directly in October 1990 during my first show at Bernard Jacobson's, my first show in a commercial gallery, when the recession had begun and doom and gloom were everywhere, and the only thing to do was to laugh. One feels very vulnerable, or at least I feel very vulnerable, when I have a show of my work on. So I took on the challenge of the subject, and began with ink and watercolour to try to paint the laugh.

But although you are saying you directly and consciously began the laugh as a subject in October 1990, this show celebrates the fact that you've been doing it for a long time.

I have painted and drawn my response to life and so what happens in my life is reflected in what I'm trying to paint and draw. After I had begun to paint the laugh, a couple of months later, I looked up 'laugh' in the dictionary. It was described as inarticulate vocal sounds expressing amusement, joy, scorn, many things. So I realised I had been trying to articulate the laugh *visually* when in fact the laugh is a physical thing and it's a sound. In much the same way as Courbet when he said he was trying to paint the sound of the deer as it came through the forest, which I think is a very beautiful thing. I didn't think that anyone had taken on the subject of the laugh before, until I discovered some of Lett Haines's half-done little sculptures. I turned one over to see what it was called and it was titled *Fat Laugh*. This only happened two or three months ago.

Did you realise that you were following on from what Lett Haines was doing? Can we talk a bit about Lett Haines?

The next painting in the show is *Lett Laughing* [plate 2]. As you know, I regard Lett as my master, my mentor, whatever you would like to call him, and he had an incisive, wicked, sophisticated sense of humour. His laugh was loud and went through many octaves, a rich scale of sound, and it was the very embodiment of him. He was also an extremely vulnerable person. I came across this photograph of him laughing. A laugh is a thing that happens, then stops, and this particular photograph had caught a marvellous moment of laughter. It was quite a delicate balance always, with his false teeth, which he designed for himself as he was afraid his face might cave in a bit if he had ordinary National Health dentures. So he designed his own personal false teeth and they didn't fit at all well, and usually in the middle of a laugh they would fall down, but this photograph had caught him when the teeth were still in place. Lett had a big sensual mouth and it was totally extended when he laughed. This completely infectious sound was a kind of primeval roar. The photograph caught that. Very few people, apart from Max Wall, who did once pose for me for forty-five minutes laughing, could do it. Most people can't. I tried to celebrate his laugh from the photograph of the magic moment before the teeth dropped.

Do you remember what he was laughing about?

No, I didn't take the photograph.

What did he usually laugh about?

14

Sex.

He usually laughed about sex?

Oh, he could laugh about anything, but very often sexual adventures caused him to laugh a good deal, both his own and other people's.

You start the exhibition with the painting Mask, *made in 1972. Why?*

In 1972 I returned to painting and knew that I wanted to paint people. Beginning again I was so constantly frustrated that at the end of every day I would scrape all the paint off the painting and put it on the palette. How this painting happened was that I took the paint off the palette and put it back on the painting. I called these early paintings my 'pudding phase'.

The mask has quite the shape of a palette to me.

Oh, do you think so? The heavy impasto paint refers to the clown's make-up, and the way that the clown sweats through this make-up and the make-up begins to run.

His one eye appears through this façade.

I think that little painting *has* got a bit of confrontation to it. It's a physical painting; you are aware of the physicality of the paint and you are obviously aware of the eye behind the mask.

Is there much laughter in this picture or is it because it's a clown that it's a notion of laughter? He looks very tragic and bruised to me.

I think it's about the ambiguity of the clown who is normally a tragic person living by being funny, so that dichotomy, that double thing, is what it's about. He's looking at tragedy and making it into comedy, that's his job.

But is he on duty here or not?

It was the idea of the clown caught unawares.

Besides Frans Hals's Laughing Cavalier, *I am not aware of any other artist who has dared to attempt the subject of the laugh and make it visual. Are you aware of anyone?*

There is a late self-portrait by Rembrandt which certainly does seem to me to be laughing, and then there is my recent discovery of Lett's little sculpture. Apart from that I can't think of any other artist.

However, I can remember in an early Tolly Cobbold exhibition a piece of work by Bruce McLean which made me laugh.

But it wasn't of a laugh?

No, it wasn't of a laugh. That was not its subject.

But it raised a smile. In concentrating on laughter, have you been concentrating on the mouth?

Not necessarily, although this year I made a charcoal drawing of a mouth laughing [plate 21]. A laugh obviously has to do with the mouth, which is to do with moisture. I suppose some people laugh dryly but a laugh is not something that I can connect with dryness. It is moist and wet. Obviously what's important is a real belly laugh. A laugh begins inside you, deeply inside you. Some people laugh with their mouth but not their eyes. A total laugh engages your whole body and is to do with what's going on inside in the head, the heart, every part of you.

It has only just occurred to me now you are speaking that your Laughs *have a lot to do with places.*

We are all somewhere all the time, aren't we? We can't ever be nowhere. We can laugh in this studio, you can laugh in the street. One is always somewhere even if one's in bed and in the land of dreams.

Have you done a bed laugh?

No.

Moving on from Mask, *which was the early clown picture in this exhibition, it is obvious that there is a link now to Max Wall and the painting* Max and Me (In Praise of Smoking) [plate 23]. *How did you meet Max Wall?*

Well, towards the end of the time I was first Artist in Residence at the National Gallery, he was playing his one-man show at the Garrick Theatre just outside my back door, as it were, and I went to see it once and found it very moving and went to see it again. He had that quality which made you want to laugh and cry at the same moment. So I wrote to him on very impressive National Gallery writing paper asking if he would ever have time to sit for me and I got a funny letter back saying, 'It's very complimentary that you would like to paint little me, I wonder what colour?' So the sittings began a month after I left the National Gallery. He came to sit in my studio in Battersea and I painted

3 *Study from Life: Max on Stage* 1981 charcoal 27.9 × 22.9 cm

4 *Study from Life: Max on Stage* 1981 charcoal 27.9 × 22.9 cm

the first portrait: *Max Wall and His Image*, which is now in the Tate Gallery. He became the subject of my work for almost two years.

And where did this one [Max and Me] *fit in and why have you chosen it?*

In most of the portraits of Max the point is the tragedy of him and in this painting I think there is a bit of comedy. About the whole notion of artist and model. I found *Max and Me* quite a challenge and the only thing of which I was certain was that the picture should be very tall as we're both rather short. It is painted as though the viewer were a bird in the air outside the window looking in at us from above.

The cigarette smoke goes into a monkey face.

It's a magical monkey being formed by the cigarette smoke. I have always been very fond of monkeys and I painted a self-portrait as a monkey listening to silence, while I was at the National Gallery.

Why is the monkey here between you and Max?

It's the spirit of ...

Monkey business?

Anarchy.

Which you are both sharing, so artist and model are very much in the same category here.

Here are two very short people, one short person trying to draw the other short person standing there.

But you are sharing more than just being short?

Well, we are both enjoying our cigarettes and are being blessed by the spirit of the monkey formed by the cigarette smoke.

What is the monkey blessing you for?

I think it's there as a kind of encouraging muse.

And what is the mood of this painting? Are you both about to laugh or to cry? You've chosen to put this in as one of the steps on the journey towards laughter, so I'm trying to get out of you why this is in the show.

Like all great comics Max was a deeply tragic person and this is the only painting of Max and me together. I like the disinterest of the cats, Rolly staring

out of the garden door, and Onde looking at the floor, and the back of Smith hidden behind a drawing at the far end of the studio.

Here are two charcoal drawings of Max on stage [plates 3 and 4]. What was he performing?

They were both done in a sketchbook during the first act of his one-man show. That's when he wore the dinner suit and the rather battered white felt hat.

In the theatre?

In the theatre. I think it was the Gardener Centre near Brighton.

And is he playing himself here?

Yes, I always preferred the first half of his one-man show, in this costume, to the second half where he appeared as Professor Wallofski. If you say 'Max Wall', most people still think of the little monster Wallofski in the tights and the wig. He said it dogged him throughout life because obviously Max was more than just that little creature he created.

Why are you including the Portrait of the Ghost of Cedric Morris *[plate 5] in this exhibition?*

To me it's a very cheerful ghost. I'd tried to paint Cedric from life not long before he died and it proved impossible. He was hardly there by then. He would sit for about two minutes, then get up and say 'Have you finished; I'm going to shave now'. He would come back into the room and go to sleep at once, then suddenly wake up and wander off again, and I had to abandon the painting. After he died, I was given the chair he'd sat in for this failed portrait, and it stood in the corner of my bedroom. One morning, when I woke up, it was as if he was sitting in that chair which I'd always kept empty. I had this vision of his ghost sitting there chuckling away at me. It was a very happy ghost and I went into the studio and took out the abandoned painting and worked on it, making the portrait of his ghost.

So the painting was begun in life, and finished when he was dead.

That's how it actually happened, yes, and it refers to the much more recent painting *Ghosts of Laughs* [plate 35], and in a way, to the *Happy Dead* series [see plate 29], which followed the *Mud Dream* drawings [see plate 12].

What does a ghost mean to you?

I believe ghosts are spirits of people who've died, and the point about the Cedric one is that he was sitting there giggling.

Some people see ghosts as terrifying things, but I don't get the feeling that they are a terrifying phenomenon to you.

Well, I haven't seen a terrifying ghost.

Have you any idea what Cedric was chuckling at?

Cedric was always giggling at something. He tended to giggle, while Lett's laugh was grander, and I think Lett's laugh quite frightened some people. But Cedric giggled at almost anything. He was very subversive, and laughter is subversive, it is anarchic.

You said Lett gave you words of wisdom; what were they?

I was actually quoting a song. As I said earlier, Lett was my mentor, he taught me that if you were going to do any good, your work had to be the priority of your life. He also said this wonderful thing of getting into the relationship where your work is your best friend, that you can go to it however depressed you are, however elated you are. Whatever condition you are in, you can go to your work, and have a conversation with it.

Can we just return to the ghost of Cedric, and the fact of his death, which you weren't present at?

Which I wasn't present at, but I'd been with Cedric in hospital in Ipswich the day before he died. He could no longer talk so I just sat there, occasionally taking his hand if it came anywhere near me, because his hands were groping and wandering all over the place. He was in a world of his own. And so I just sat there looking, and it made a strong impression on me. The next morning, back in London, I made the drawing from memory of Cedric in hospital [plate 6]. And they telephoned me at a quarter to one, just after I'd finished, to say that he had died.

The drawing shows someone holding his hand.

That is Millie's hand, Millie who looked after Lett and Cedric until their deaths.

But was she there holding his hand?

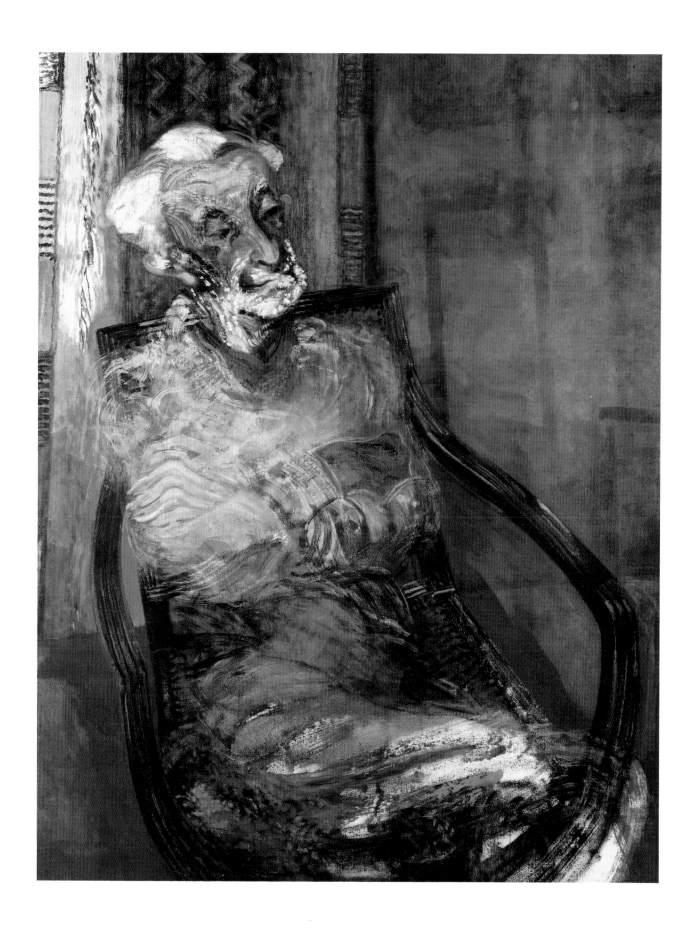

She was. I'd taken Millie to see Cedric and she was holding one hand and I held the other if it came anywhere near me. And so the order of events was: the abandoned portrait from life, then the drawing made from memory and the experience of his death, and then, about six months later, the visit of the happy ghost.

Can we now move on to consider your series of Sunrises? *You've made a habit of going to paint the sunrise on the River Orwell in Suffolk each year in the second week of July, and you started that in 1984. What we've got in the exhibition is* July Sunrise, Orwell Estuary I [*plate 24*]. *Why did you decide to include this particular work?*

I think it's one of the most cheerful paintings I've ever managed to paint. It was done terrifically quickly, in about twenty minutes.

Was it actually done in front of the motif?

Yes, on the spot, and it's the only oil done on the spot.

I see it as a happy picture and a funny picture.

I think it's quite a funny little picture. The black marks which are a part of the sun do look like an eye and a nose and a mouth, so the sun is smiling.

Coming up smiling?

Yes, I hung this picture at the foot of my bed and it stayed there for a year.

Why? What did it do for you?

It made me feel cheerful when I woke up in the morning. It was also rather a mystery. I didn't grasp its significance and it was a year later that I brought it into the studio and made a second, much larger version, which is now in the Harris Museum in Preston.

And what is the significance of this little painting which you didn't grasp when you made it?

It was the beginning of the sunrise, a subject which occupied me for a number of years.

For six or seven years, I believe. Is laughter connected with the sunrise?

I have always felt the sunrise is more optimistic than the sunset. The sunset is tragic in an obvious way, because it's the end of the day and you've had it by then.

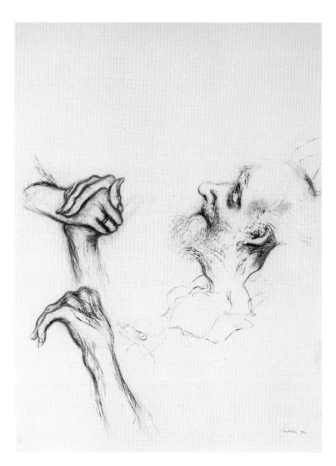

6 *Cedric, February 8th, 1982* 1982 charcoal on paper 76.2 × 55.9 cm British Museum

I'm very much an early morning person, and I feel there is all the optimism of the possibilities of a new day.

In the exhibition there's a small portrait of a woman lying back on pillows, laughing with pleasure and delight [Laughing Portrait, *plate 25*]. *I find this a very sensual picture.*

I'm glad you find it so because that is exactly what I was trying to paint; someone happy, completely relaxed, abandoned if you like, laughing. It's about abandonment and laughter and pleasure.

What does it celebrate?

Well, it's a very intimate laugh.

Can we now discuss Dragon Sunrise, *1986* [*plate 26*], *which you describe as a cheeky picture. I can see for a start the creature in the sky, which is a theme I know you have returned to many times.*

Dragon Sunrise is quite a funny picture for me but then this touches on the nub of the matter. What makes one person laugh makes another person cry; there is no accounting for what makes someone laugh. Often in the theatre at the most tragic moment, a good part of the audience bursts into laughter, because they can't cope. It's laughter in self-defence.

Was this oil developed from a watercolour?

Yes, a watercolour done on the spot on the Orwell Estuary. The formation of the clouds combined with the sun to create this dragon in the sky, and I used the watercolour as a starting-point for the oil, although there always comes a point when I'm using a drawing or a watercolour for a painting when I have to turn it to the wall, so the new piece of work can have a life of its own. I think the dragon confronts you in quite a cheeky way.

In what way is the dragon cheeky?

The top half of the dragon, the black and white bit, looks as though it is in evening dress and the bottom part of the dragon, showing its parts, is undressed, is naked. I also think the painting has an explosive quality, which is very close to laughter, the way laughter explodes. A sudden explosion of laughter chasing the blacks away.

Are the blacks the trees at the bottom?

Yes, the trees, the distant bank, the blacks of night are being chased away, dispelled, being forced out of the painting.

What do dragons mean to you, and how long have there been dragons in your life?

I think that dragons exist; I know there are lizards on the Cayman Islands that are called dragons, but a dragon to me is actually an imagined creature, and I suppose everybody has their own dragon. A dragon is the spirit that makes art happen, is a magical, energetic force like a muse. Because there's no doubt that one is not in charge of when a painting or drawing finally happens. You are not in charge. As Brancusi said, it isn't difficult to make a work of art; the difficulty lies in being in the right state to do it. I suppose you're constantly trying to be in the right state to do it, and mostly you're not, otherwise you'd be producing masterpieces all the time. You can't tell at all when the muse is going to be with you and something is going to go right, and I think when my dragon is active and working, that is the time when something happens.

It's obvious that by 1984 and 1985 in your Sunrises *that there was a brightening of your palette. Was this because you were happier? What is the reason for the brightness?*

How can one tell these things? I mean, Max

Wall wasn't about bright colours, he was about things being very black, very white and every conceivable shade of grey in between. My imagery of Max is therefore sombre. Cedric didn't go in for wearing bright colours. He tended to wear earth colours, coming in from the garden covered in earth as well. The point about the sunrise is that it is the time when there is most colour in the sky. People always refer to my *Sunrises* as my sunsets because they're not used to being up at the time you need to be up to see a sunrise. But everyone's seen a sunset, and I agree, of course there's a lot of colour in them. In the very early morning, the sunrise is like a sexual thing. There is the build-up of the clouds waiting for the climactic moment of the appearance of the sun and you see the effect of the sun on the clouds long before you see the sun. So the sun causes all these colours to charge around the sky at a terrific rate in extraordinary formations. So I responded to Max, to the colours he was, and I responded to the colours I found in the sunrise.

You've brought brighter colours from your Sunrise *phase into the more recent* Laughs. *Or are there some sombre laughs?*

Well, *Ghosts of Laughs* [plate 35] is hardly a riot of colour.

How do you move from a sunrise to a dead bull? [*see plate* 7]

I worked through a time of painting the bullfight and the sunrise concurrently. It was David Sylvester's idea when he hung my show at the Serpentine Gallery in 1987 to hang the bulls and the sunrises in one gallery, and they worked very well together. In an obvious way the sunrise is about something moving up, and with the bullfight, the bull who comes into the ring proud, erect, his head in the air; during the course of the fight, first his head and then his body gradually descend to the ground.

So it's a tragic notion?

I think the thing about the bullfight is that it's an allegory, if that's the right word, of life. We are born innocent and inquisitive and spirited, and life can break down this spirit and your innocence disappears.

Since you've painted yourself as a Welsh Black Heifer, you must be identifying with this animal in a way.

I don't know about the word identify, but I think I identify with whatever subject I'm painting. You

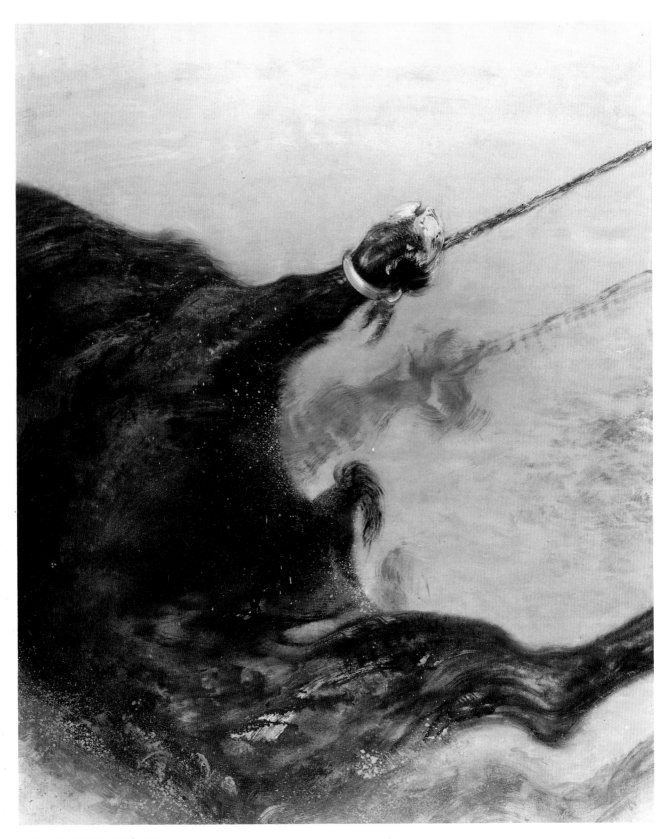

7 *Dead Bull* 1987 oil 94 × 76.2 cm (cat.8)

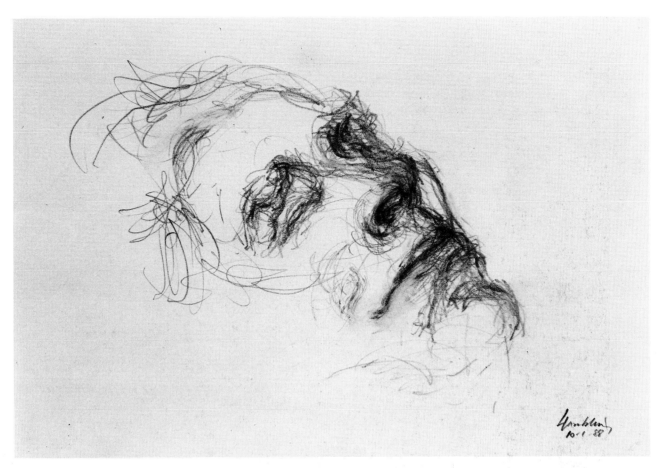

8 *Study from Life: My Mother Dead, 7* 1988 graphite
19.7 × 29.8 cm British Museum

can't paint anything unless you're at one with the thing, it's inside you, it obsesses you. If it comes out right you've been the right vehicle of the subject, the subject has come through you.

Would you say that your seven or eight bull paintings are really only about tragedy and sympathy, with very little happiness or laughter in them?

The painting *Dead Bull* is clearly about the fight being over. It's about the fact of the bull's death, the removal of the body, the body being dragged away from the ring.

When did your mother die?

January 1988, early January 1988.

Were you with her?

No, I'd been with her the weekend before she died. She died on a Tuesday. A woman of iron will and the doctor had come and said very quietly to me that she ought to go into hospital and although my mother was deaf she certainly heard this extremely small whisper and questioned me about it when he'd gone. She firmly made up her mind that she was not going into hospital. I think it really was as if she had decided that the moment had come. She'd been dressed, she stood up, she sat down again and died. My father was there. I made drawings of her lying in her coffin [see plate 8]. Whenever I'd drawn her while she was alive she would always take off her spectacles and constantly arrange her hair. She was not very good at sitting still and this was the stillest I ever had her, and she did have on her face this half-smile of contentment. She looked completely at peace.

What did you inherit from her? If she had an iron will, what have you got that's like her?

10 *Breaking the Moon* 1989 oil 243.8 × 121.9 cm (cat.12)

I think I'm pretty determined, and she always said I was very obstinate.

Did she want you to be a painter? Did she mind you being a painter?

I think my parents realised they would just have to accept it. As you know, when my father was sixty-five, he began to paint. He's an incredible painter and still at it at ninety-one.

Are you afraid of dying?

I'm a bit like that saint, I don't want it to happen yet.

Which saint?

The one who said 'I want to be good but not yet'.

Drowning Sunset [cat.10] was painted the month after your mother's death and seems to express mourning, the end of something.

Not long after my mother died I did some work for the show at the V&A, *Artists in National Parks*, and I chose the Pembrokeshire coast with a view to seeing the sunset. I had said earlier to my friend George Melly, it's extraordinary how you seem to have much better sunrises on the east coast and better sunsets on the west coast and he pointed out that it was possibly to do with the fact the sun rises in the east and sets in the west. I went to the Pembrokeshire coast to make watercolours of both sunrises and sunsets. The sunrises weren't too good, because they were often covered in mist but the sunsets were pretty amazing. This painting does not come from a watercolour, it comes from memory and imagination of a Pembrokeshire coast sunset, and it closely followed my mother's death.

What does it express?

It's called *Drowning Sunset*. The sun really disappears *beyond* the water but looks as though it's disappearing *into* the water.

I'm interested in the idea of a watery sunset. We said earlier that the Laughs *had a moist watery quality. Is there any link?*

Water and the sea are very important to me. If I haven't seen the sea for a few months, I have to go and contemplate it again.

9 *Breaking the Moon* 1989 ink 57.2 × 38 cm

Can you equate the sea with the mother or with death?

James Joyce did call the sea 'the sweet grey mother', and I suppose if I was at all in charge of how I died, I'd like to drown peacefully, if that were possible. That's why I practise floating on the sea. I'm not a good swimmer at all, I can hardly swim, but I'm very good at floating.

This is the second method of death we've had. Earlier you said it would be nice to die laughing and now you'd like to drown peacefully.

If you could drown laughing, possibly with the aid of a little alcohol, it might be the way to go. Much as the kindest way to kill slugs is to give them pots of beer so that they will at least die drunk.

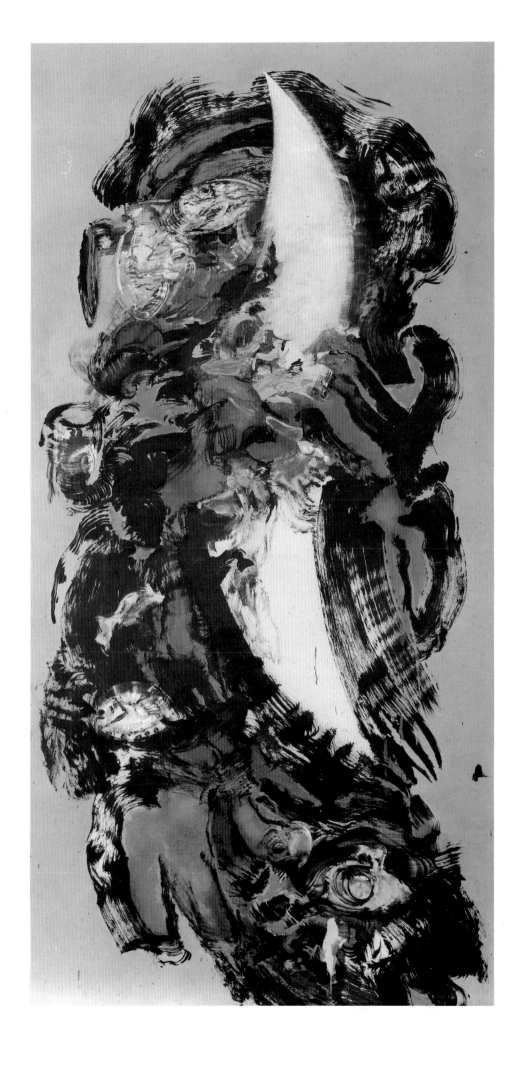

August Sunrise [cat.11] is a large red and blue canvas with what looks like an eye at the top. I remember you telling me that the scale of it is because you'd been to Florence and seen Michelangelo's Slaves *and they inspired the vertical format.*

In an obvious way it is to do with the upward movement of the sun. It was after looking at Michelangelo's *Slaves* in Florence that I realised that was the proportion I wanted for these paintings. In fact *Drowning Sunset* was the first vertical painting. *August Sunrise* is one of the early *Sunrises* of this shape and it's the first one from the imagination. It followed a lot of ink drawings. I was trying to ask myself, you have to ask yourself sometimes, why you are painting a certain thing and I was experimenting, trying to get at the essence of these sunrises.

But why is it in this exhibition?

Well, I suppose you could say the sun dies in *Drowning Sunset* and rises again in *August Sunrise*.

In the hot time of the year. It's cheeky with that eye at the top.

It has come out as half human, and this was happening in the ink drawing, the emergence of this figure. A skull or an embryo, an eye looking out at you from the top.

But I'm asking the question: is it to do with laughter?

I think it has some of the same cheek as *Dragon Sunrise*.

Breaking the Moon *[plate 10] is a canvas painted shortly after, which I find very threatening and serious and you don't. You feel it has a humorous side.*

Well, of course the whole notion of breaking the moon is pretty preposterous for a start.

Did you dream it?

Yes. It came to me as a lot of my paintings do, in dreams. In this dream the moon was being broken and I made a lot of ink drawings of it.

And it wasn't a threatening subject to you?

Yes, of course it was. You think of the moon as always being there. It's one of the constant things in life and the notion of it being broken, which seems to me

something that man in his wisdom might do, is horrifyingly possible.

There is a large canvas in the exhibition, Between Sun and Moon, *1990 [plate 28], which is a self-portrait of the artist, bowed down by grief. I have to say, with my art-historical knowledge, that it very much brings to mind the subject of the crucifixion, in which Christ is always portrayed bowed down between the sun and the moon, between the sixth and the ninth hour, between light and darkness.*

I certainly had no idea of painting myself as Christ. The painting happened very quickly. Three people had died, one after the other in the space of three weeks. Max Wall, Peter Fuller and Nancy Dennistoun. So, bang, bang, bang, these people died in a very short space of time, and I think one of the difficulties about people close to you dying is that you go on living, very obvious but true. So I was trying to paint what I felt about these deaths around me, and my going on being alive.

And being a painter, was this one of the ways of handling grief?

I think artists of any kind are very lucky in that they have a means of expressing what they feel, which a lot of people don't.

So can we say that the laughing portraits celebrate the happy moments, and Between Sun and Moon *is a way of expressing your grief? At the same time as, or very close upon,* Between Sun and Moon *I believe you painted another large oil,* Artist in Hot Studio, *and there is a lively ink drawing of this [plate 11].*

Yes, that was made during the heat wave of 1990. I was using the masking fluid as in the moon drawings. *Artist in Hot Studio* was done with masking fluid, ink and the left hand, and it is a self-portrait. It refers back to the painting of me with Max Wall in my studio, smoking. In this image, I have my brush in the right hand, cigarette in the left. It was about it being so hot and being alone in the studio. I spend a lot of time wondering what on earth I'm doing.

Have you ever answered the question of what you are doing?

No, I don't think I'd bother to do it if I could answer that. I was having a lot of trouble with my teeth. You see the teeth feature quite heavily.

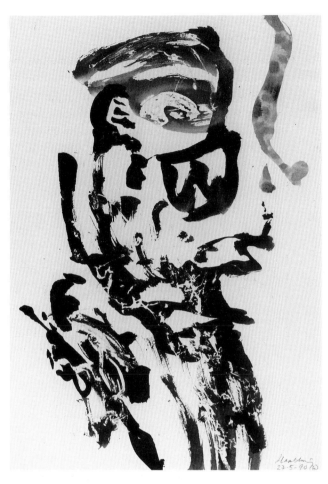

11 *Artist in Hot Studio* 1990 ink 41.9 × 29.8 cm

In Berkshire, on the night of 4 and 5 August 1990, you had a very significant dream which caused you to execute seven Chinese ink drawings on paper which we now call Mud Dream [*see plate 12*]. *You have written about this dream, and I know it is about death and submission.*

I was lying either on the earth or in water, and this mud began to approach me from all directions. It was yellowish, gritty, liquid mud and it came at me at an alarming rate. I was completely on my own in the dream, but I said out loud, 'It looks like this is it and there's nothing I can do about it'. I knew the mud was death and I accepted it. It engulfed my whole body, finally my eyes, and I died but went on dreaming and was still alive, even though I was in limbo, if you like. It was a completely positive dream about death so that nothing ended with

death, and it was this acceptance both of death and the fact that one was still there after it. That's what made it such a significant and important dream, and immediately next morning I made the series of *Mud Dream* drawings, which are really one work. And the morning after that, the painting *August Night* [cat.14] was completed. And the whole of the bottom half of *August Night* refers to the mud, the experience of the dream.

But August Night *is more than a painting about this yellow gritty mud.*

I do remember in the dream that the eyes were the last thing to go, although I suppose if one's nose and mouth were full of mud one would have stopped breathing. I should think most painters wonder what would happen if they went blind, whether that would be the end of everything. I know what I would try to do, I would try to write poetry. *August Night* is about love and death with a pair of lovers at the top of the painting. The lovers are contained within this dark, giant figure. It's as if the lovers are in its embrace. They are held by this dark figure of night. The terrible thing is, if you love someone, the fact of their death.

There's a series of six watercolours which actually used to be called The Far Side, *and are now called* The Happy Dead [*see plate 29*], *which come after* Mud Dream, *after* August Night, *and are a celebration of death.*

Mud Dream led to this series, celebrating life after death. They have to do with the sunrise and dead people lying in the ground looking up at the sky, very often with water flowing below them.

Are the lovers reunited or united or is it a kind of resurrection?

It's an imaginary vision of people dead who are happy. Obviously you can refer back to *The Ghost of Cedric*. The fact is that we don't know what happens to us when we die. We may very well be laughing. After all W.C.Fields had inscribed on his gravestone: 'It's better than playing Philadelphia'.

There's a small canvas called The Happy Dead [*plate 30*] *painted after the sequence of watercolours, which sums up what went on in them.*

I don't know about summing up – I hope that each of the watercolours works in its own right. I got rid of the ones that did not. This is the first canvas that I painted Indian Yellow, using what's called a sponge brush. That's a piece of foam rubber on the end of a stick, which I'd discovered in an art shop at Yale when I'd gone to see the Yale Center for British Art before my show there in 1991. I applied the thin wash of Indian Yellow, the first coloured ground I'd worked on; Indian Yellow has a luminous intensity. The painting painted itself in about twenty minutes. It just happened, so I left it. When I came back to the studio afterwards it made me laugh.

In Mud Dream *you say that you had drawn with the masking fluid first. What is masking fluid?*

Masking fluid is a rubbery liquid that you can use in any way. In the *Mud Dream* drawings I used bamboo sticks to draw with it. That's how the *Laughs* began, drawing with the masking fluid, and then very quickly after that, throwing the masking fluid onto the paper.

Is it white on white?

The liquid is a whitish colour and you can throw it, drip it, pour it, what you will, onto the paper, and then

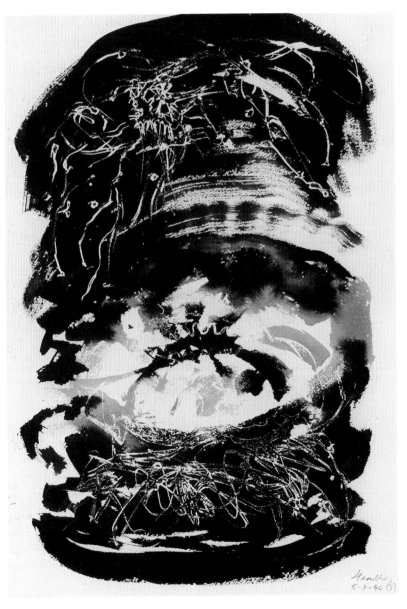

12 *Mud Dream, V* 1990 ink 50.8 × 35.6 cm Tate Gallery

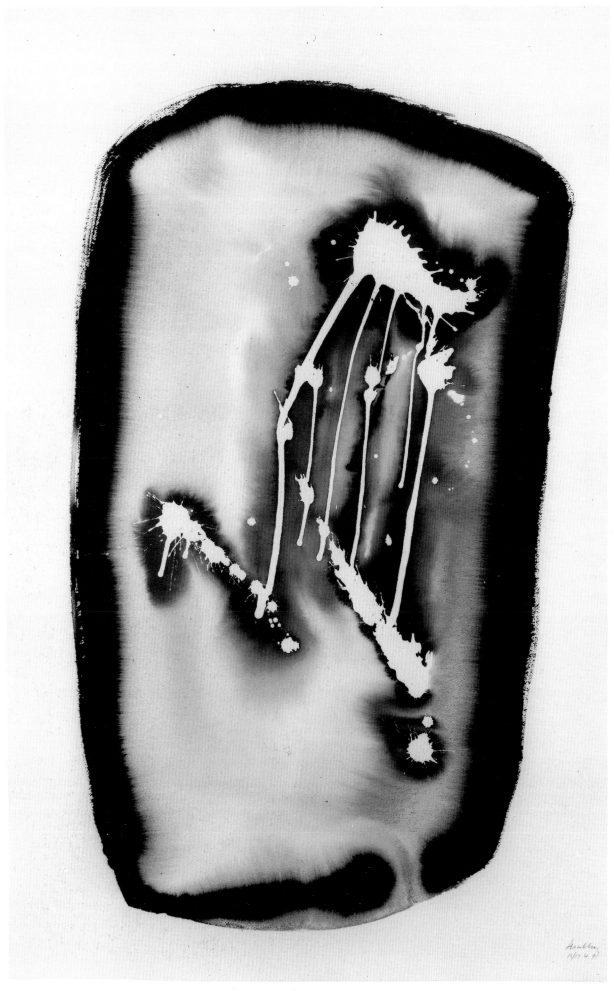

13 *Interior Laugh* 1991 watercolour / ink 101.6 × 63.5 cm (cat.38)

allow it to dry. It dries yellowish, and obviously stands proud on the paper. And so the *Laughs* began. I worked with the watercolour and ink in response to the drips. The masking fluid had done the drawing. It was October 1990 when I began to try to paint the laugh. There were a lot of watercolours, and around Christmas 1990, I started to try to make the *Laughs* in oil. But they didn't work at all, and I destroyed them and went back to watercolours. At the beginning of 1991 *Laughing Creature* [plate 31] was done, and *Interior Laugh* [plate 13], and *Night Laugh* [cat.19] and *All Souls' Laugh* [plate 32].

Can I ask about the titles?

All Souls' Laugh was made the morning after a particularly good dinner at All Souls' College, Oxford. I didn't know when I did it in February 1991 that it was a seminal work in relation to the sculptures which happened this year.

But these watercolours also lead into the paintings, which we are now going to discuss.

I worked with watercolours again in January, February and March 1991. March has always been for me a pretty creative month of the year. I feel a lot of energy, the sap is rising, everything is thrusting up through the ground. So there is a lot of sexual energy inside and out in March, which is when the painting called *Onion* happened [plate 33]. I worked largely on the floor, using the foam brushes again. These foam brushes were a great discovery. After years of painting you get so full of tricks using ordinary brushes. Working with the left hand was also an attempt to get away from the tricks of the right hand. Mars Red is the surrounding ground of the onion and there is Indian Yellow again and the Cadmium Yellow Deep was applied with a knife. The tiny marks higher up the onion are done with a sable brush, so it is a great mixture. It happened very quickly , and I called it *Onion* because it was to do with things thrusting up. Other people may interpret it as something else. I don't issue orders with the paintings, how they should be seen. If a painting can't speak for itself, and obviously it speaks differently to everyone, then there is not a lot of point.

As 1991 progressed you made more oil paintings, and we have got two in the exhibition that I'd like you to talk about – Christmas Laugh (In Memory of my Mother) [plate 34] and Spanish Laugh [cat.18]*.*

Christmas Laugh was the first oil which began with throwing very liquid white oil paint onto the canvas, in the same way that I had used the masking fluid for the watercolours. That was the first one, and although it is quite difficult to tell now when you look at the painting how many layers went underneath, there were many. I worked on the painting for at least two months.

Was it like the pudding phase, scraping on and scraping off?

No, I wasn't taking things off so much. I was working more thinly, and then at a point I gave up, and painted the entire canvas mid grey, just getting rid of everything that had gone before. One Monday morning, a bit of something came from somewhere. I can't account for when things go right, when the dragon is going to be with me. The grey was by now dry and I mixed in a jar this very liquid Alizarin Crimson and worked with the foam brush, very quickly, on top of the grey, and the grey and the red seemed to do something.

What?

They had a sort of frisson, if you like. I left it for a few days, and then made the rather loud pink shape, which stands out from the rest and which is in fact my mother. It's called *Christmas Laugh (In Memory of my Mother)* and it came to me what it was about in the course of working on it. It concerns the tensions in a family at Christmas, when it's very important that everyone is happy together, and merry and laughing, and I realise my mother was the commander-in-chief of all this fun and laughter, and wanted to be surrounded by it.

Did you set out to make the pink shape your mother? What made you identify that with your mother?

It showed me, it said to me that's what it was. I know there are people who have called some of these early *Laugh* paintings abstract, and although I don't see any war myself between so-called abstraction and so-called figuration, they are not to me abstract paintings. This refers definitely to a human being in a particular place. So I see nothing abstract about it.

While people might wrongly use the word abstract, they haven't got the knowledge of how you read the shapes, have they? They are very personal things, so they need help with the imagery, with the subject. Does the title help them to find them not abstract?

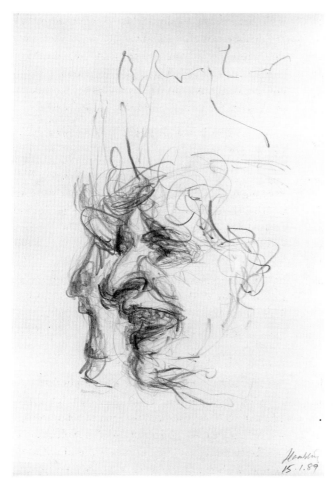

14 *Laughing Self-Portrait in Paper Hat* 1989 graphite
29.2 × 19.7 cm

Well, you would have to ask them,
wouldn't you?

*You are showing me in one of your sketchbooks
a drawing made in 1989 called* Laughing Self-Portrait in
Paper Hat [*plate 14*], *and this has been significant to you.
Why?*

As I got more into the subject of the laugh I
suddenly remembered this drawing one day and then
looked at it quite often. I kept it handy in the studio. It
was done from a photograph taken at Christmas, the
Christmas of 1988.

The first Christmas without your mother?

Yes.

After Christmas Laugh *the next chronologically
is* Spanish Laugh. *Would you like to tell me something
about the technique of this work? The colour, the way you
painted it and what inspired it?*

As in *Christmas Laugh* there were many throws
of paint at various stages. I felt it was a dancing painting
and the red is much brighter than in *Christmas Laugh*.
The combination of the red and the black with the throw
of pure white paint in the top left-hand corner, which was
the last thing to happen, seemed to be a kind of dancing
fandango.

Do the titles always come afterwards?

They come during the course of the painting.

*Do you work on more than one painting at a
time?*

There's no rule about that. I can concentrate on
one painting for a month and then put it on one side
completely, and not touch it again for another two
months.

Night Laugh [*cat.19*] *is one of the simplest
images you've made. A great, strong, formal shape. Tell
me about this one.*

It was one of the quickest paintings to happen.
There was the original throw of the white paint, which
with the Alizarin Crimson became this rather sexy shape.
French Ultramarine followed and all the paint went on
with sponge brushes. I realised that it referred very
directly to the *Night Laugh* watercolours that I had
already done and I think it is possibly the beginning of
the paintings becoming more sculptural. It is a red form
in a blue space.

Ghosts of Laughs *has quite a different quality,
I feel, because it has a subterranean, watery, subdued
palette.*

This painting started out in life as a laughing
grandmother undressing. And it went through many,
many changes, and so it was a sort of ghost of itself. A
friend of mine said that it was like wandering at the dead
of night through a house where there had been a party,
and hearing the laughs still going on. I liked that response
to it.

So it's got quite a happy mood?

The laughs had happened, but they are still reverberating, as ghosts of laughs, and so, I suppose it is to do with laughing after death.

Avebury Laugh [plate 15] refers to the marvellous site in Wiltshire, with two stone circles, the Iron Age centre, a spiritual centre, doesn't it?

Well, apart from the two stone circles there is a long, grand monumental avenue of stones. Early one Sunday morning, being with those stones, and of course the place is a spiritual kind of place, I thought it was a good place for a laugh. Why not? You are aware of all the people in the first place who erected these stones, and all the people who have gone for various reasons to be with these stones. This is not a painting of a particular stone. I came back and made watercolours from memory and imagination of these stones, and then the oil happened.

You have done some drawings and paintings of elephants with that wonderful tough hide and I always get a slight elephant feeling with this work.

Yes, other people have too. Bulls, dragons, elephants – things come up again and again, and you realise afterwards that you are painting things first done many years ago.

Champagne Laugh [plate 36] has the same intense yellow ground as The Happy Dead. *Is there therefore a connection?*

The yellow was again applied with the sponge brush, more or less all over, and then removed. A lot of painting is not about putting it on but taking it off. The Indian Yellow was removed and the pink happened. It's about that kind of high brittle feeling while drinking a lot of champagne.

I don't want to tie this down but is the painting a reclining nude?

Certainly. It's a reclining nude: her legs up in the air, the top of her head towards us, and her face reflected in the mirror on the right. Her arm is extended up with a glass of champagne.

I've just noticed that the large Laugh *paintings have got a format of 7 feet by 5 feet. How did you arrive at this proportion?*

The vertical shape I was working on before didn't seem to be expansive enough for this subject.

The narrower vertical ones were more about the sun and moon and that connection, weren't they?

Quite so.

Brothel Laugh [plate 37] has quite a bawdy feel to it with all that pink. Are those buttocks?

They could very well be buttocks. I've never been to a brothel, but I've always found the whole idea pretty exciting, and I'm sure there must be a few laughs in brothels. This is the first painting in which I worked in the liquid white paint with my fingers. And there are throws of flesh colours. And this vibrant pink, this rather terrible pink and the black actually came, I realised after a bit, from the colours of the packets of Kayser Bondor underwear that I remember from my childhood. The violent pink and black packets of ladies' underwear. And the little card, just over half-way up on the right-hand side, was essential for the scale of the body.

Which is huge.

Which is huge, because I tried to make it grand and monumental, and I was trying to paint the essence of what a brothel is about. The little card, such as you see everywhere, says 'French Model Third Floor'.

This painting was shown in the Royal Academy Summer Exhibition of 1992, and there was a great variety of critical response to it.

Ah, yes indeed. Giles Auty in the *Spectator* felt that it completely let down Gallery Seven, which otherwise was apparently full of quite good pictures. Richard Dorment of the *Daily Telegraph* went further to select it as the 'single most awful work at the Academy'. He described it as 'awesomely terrible', and a 'semi-abstract evocation of a womb greatly magnified from a gynaecologist's point of view'. 'This work of art, which is very pink, belongs in some bad taste hall of fame. Well played, Maggi!' Tim Hilton in *The Guardian* liked the painting, I think, but described it as 'indelicate even by her formidable standards'. One of my favourites was anonymous in the *Economist*. It read, 'English painting has been slow to benefit from the revival of serious figurative art. Here, still, many of the best works are abstract, or comic or both: there is a wonderful pink confection called *Brothel Laugh* by Maggi Hambling,

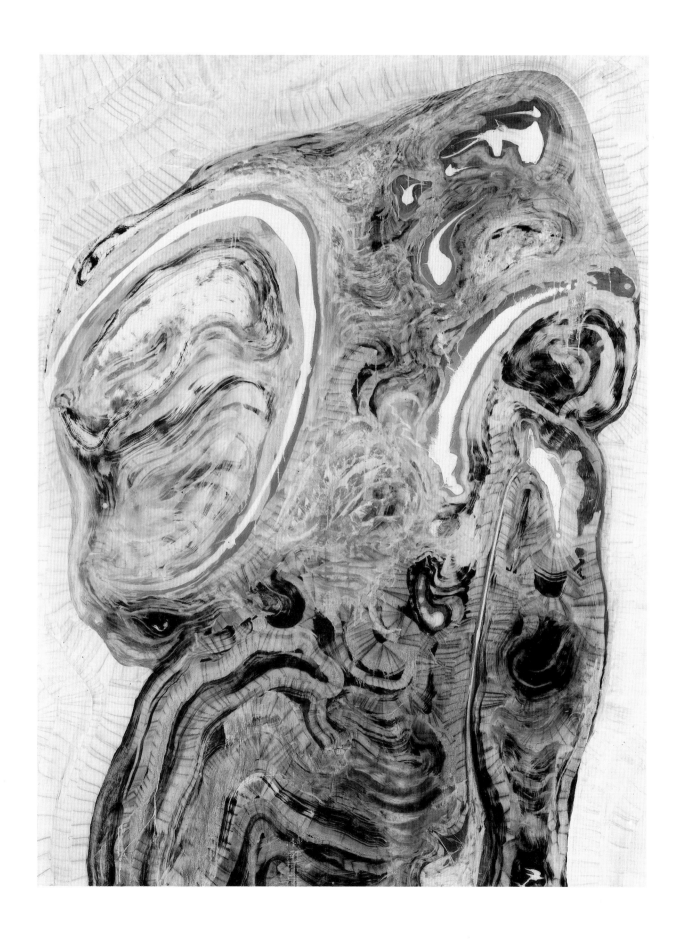

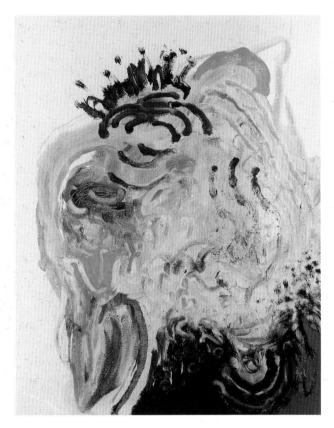

16 *Sprouting Person* 1992 oil 50.8 × 40.6 cm (cat.28)

which is suggestive if abstract, and exceedingly rude if not.' I quite enjoyed all this, because I am particularly fond of Oscar Wilde's remark that when the critics are divided, the artist is at one with himself.

Secret Laugh [*plate 38*] *has the same Indian Yellow as* Champagne Laugh.

This intense Indian Yellow does seem to me to have the kind of fizz of the laugh. I see this painting as two heads really; a woman on the left having a secret laugh in the mirror, or else the mirror could be another woman, and they are having a laugh between them. This painting stood around for a very long while without being finished. And then on a certain Friday morning I knew what to do. Permanent Rose went over the throws of white at the bottom of the painting, and up into the neck of the head on the left.

I read Bathroom Laugh (Self-Portrait) [*plate 39*] *as coming out of* Spanish Laugh. *A wonderful figure doing the fandango in a blue and white room.*

All that blue and white comes from the idea of china tiles. There had been many paintings on this canvas and so there was this accumulation of paint. And I saw myself at a very odd angle in my bathroom, of which one whole wall is a mirror. And it comes from that. You know you can never really see yourself from the back and all that, unless you have mirrors all around you.

What is the oval form?

The oval shape at the bottom right is a little glass table that you might have in a bathroom, reflecting private parts.

Do you see yourself as comical in the bathroom?

Oh, most certainly. Very few people are completely happy with their bodies. And I'm no different.

Laugh Defying Death [*plate 40*], *a very complex painting, was inspired, I believe, by your visit to the Giacometti exhibition? Particularly by* Woman with Her Throat Cut, *a bronze.*

That's right. I had gone early in 1992 to the Giacometti show in Paris. And the work that I returned to again and again was *Woman with Her Throat Cut*. It's a very powerful work, and a very sexual work in the way the parts of her body have been laid out, and the piece lies on the floor. When I got back from Paris there was a canvas waiting with its throws on to be the next *Laugh*. It's as if Giacometti's figure is rising up off the floor.

Is it a resurrection?

You and your resurrections! No. It's about the laughing figure challenging death, it's about the confrontation between the figure and the door on the left, which is death.

Suicide Laugh [*plate 41*] *follows on from* Laugh Defying Death. *Black ground, sombre work.*

I agree with you it's a sombre work. A painting I've never been able to forget is Andy Warhol's *Woman Suicide*, which I first saw in the Tate exhibition *Picasso to Lichtenstein*, I think. It was a multi-image silk screen painting from a photograph, and it remained with me. I felt I was standing there in front of the building, and the woman was falling off the building in front of my very eyes. It had that kind of electricity. And this piece of mine, although it is from the imagination, is very much to do with that. It's about the moment of a woman jumping off a building, surrounded by laughter or

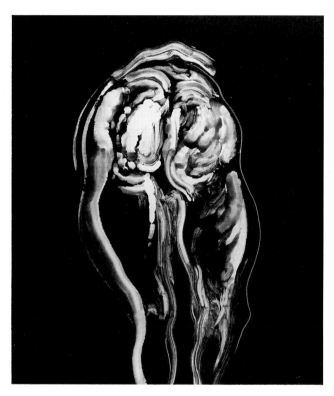

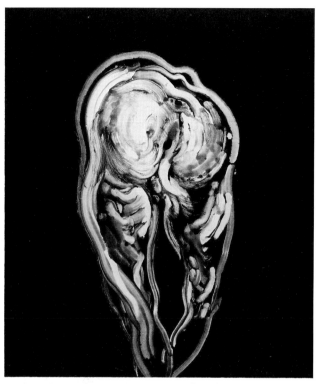

17 *Study from Life: Jemma, Back View* 1992 monotype
image: 55.9 × 49.5 cm, paper: 74.9 × 57.2 cm

18 *Study from Life: Jemma, Back View* 1992 monotype
image: 55.9 × 49.5 cm, paper: 74.9 × 57.2 cm

laughing herself, I don't know. The paint of the body is
done more than ever with the fingers, and moving the
paint around with my fingers. You may remember the
painting *Laugh in the Bottom of a Well*, done last year,
which I destroyed. I destroyed several more and only
kept *Laugh Defying Death* and *Suicide Laugh* out of the
big paintings last year. They both concern the human
figure. I am essentially a painter of the human figure and
Laugh at the Bottom of a Well had got far too abstract
for me.

*Saying that you've destroyed several large
paintings from 1992 makes me wonder whether perhaps it
was a very difficult year for painting.*

There are so many bad paintings in the world,
I don't want to add to their number. In the end one is
one's own best critic, and I'm extremely self-critical.

*In the Autumn of 1992 you painted a large
watercolour [Self-Portrait, plate 42], which we now know
relates to the series of marvellous clay sculptures you've
just made.*

Yes, it's the largest watercolour I've done to
date. There's an eye on a pair of legs with various other
bits attached. It's a self-portrait. What is a painter but
an eye? And a painting or drawing is a human thing,
made by a human being, and a human being looks at it.

We started by saying that the Towards Laughter
*title referred to your journey through life. This large
watercolour self-portrait and a small painting* Sprouting
Person *[plate 16] seem to me to be another step on the
journey, but are laughs still the foremost thing in these
two works?*

I find the self-portrait amusing but it's a tricky
subject. I can't sit here saying these paintings are
hilarious – some people find them the opposite. But that
goes back to the laugh being a very serious business.

Yes.

The sculptural thing had begun in *Night Laugh*
and is certainly there in both *Laugh Defying Death* and
Suicide Laugh. The self-portrait is like a creature in

space. And the little painting *Sprouting Person* came at the end of last year when I was working much more with my hands, something that had begun in the monotypes [plates 17 and 18].

And the importance of this? In 1993, you've made a series of sculptures in clay. And you're telling me that the sunrise, the laugh and the creatures have all come together in these works.

If you take *Hermaphrodite Self-Portrait* [plate 43], one of the latest sculptures, it is a three-dimensional version of the watercolour self-portrait. The paintings were getting more sculptural and I was working more with my hands. Then I started working at the Royal College with clay and everything came together. And the sculptures, although they began from the sunrise, became more to do with the laugh. They are the most recent manifestation of the laugh in my work.

We know that Matisse, a painter-sculptor, when he wanted to find out something new about himself, turned to sculpture to resolve something in paintings. And I think this has helped you too, hasn't it, this sculptural phase?

Yes. Lett always said when you get stuck, change your medium. These were very dark winter days with no light, and the opportunity arose to make something in which you didn't really need daylight. And so working with clay for a few months has made me aware again of the stuff of oil paint, excited by it.

We started by talking about the subject of laughter, and what laughter does to one. It's an odd, bizarre moment.

It's this mysterious business of what makes one person laugh makes another person cry, but if you laugh with someone, you feel *at one* with them for a moment in this lonely business of life.

It sounds to me rather like Samuel Beckett.

Yes. His humour is a fundamental part of his work. Beckett confronts the loneliness of life, the inevitability of death, and there's a great deal of humour in the way he does it.

I've been told that when people have seen your clay sculptures they chuckle. So it seems to me you are adding to the sum of laughter in this world.

Well, thank you, but I'm not an accountant. I agree with Matisse when he said all artists should have their tongues cut out for the amount of rubbish they talk about their work.

OPPOSITE

19 *Advancing Sun* 1993 high-fired clay with engobe
29.2 × 47 × 20.3 cm (cat.41)

20 *Laughing Dragon* 1993 high-fired clay with engobe
27.3 × 35.6 × 20.3 cm (cat.42)

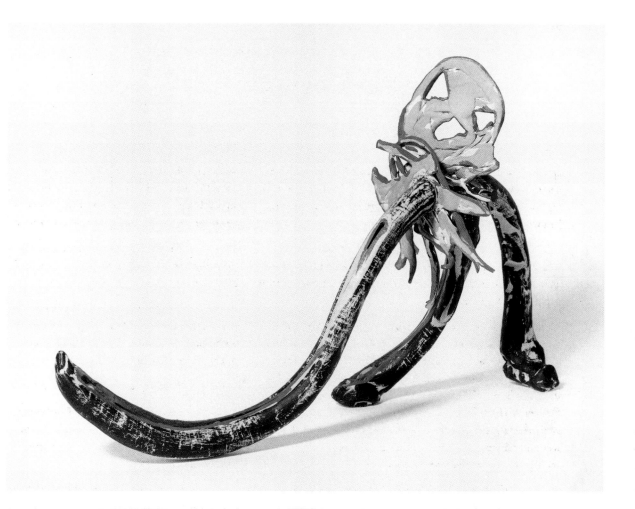

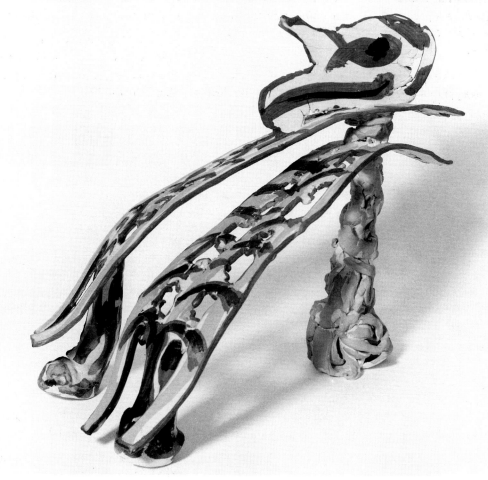

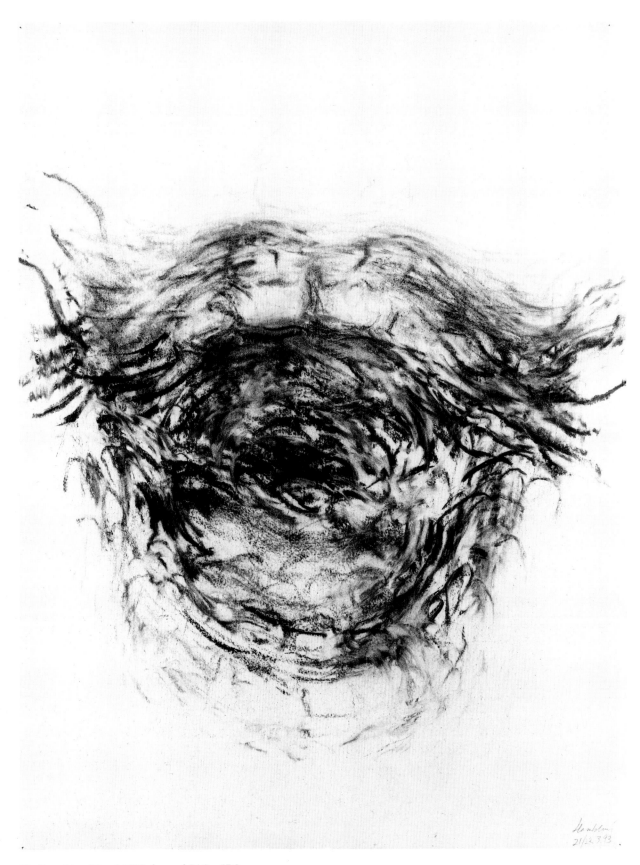

21 *Laughing Mouth* 1993 charcoal 76.2 × 57.2 cm

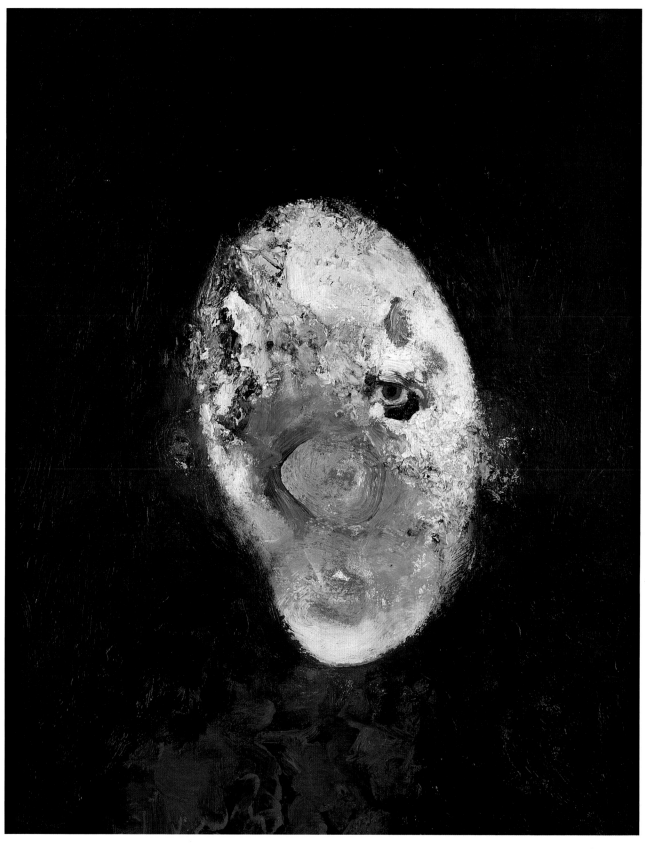

22 *Mask* 1972 oil 50.8 × 40.6 cm (cat.1)

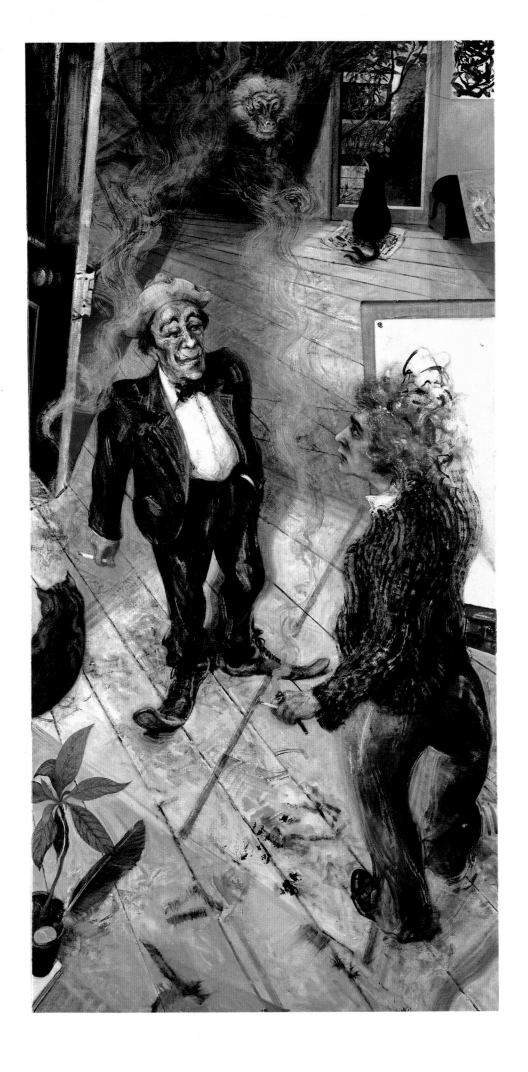

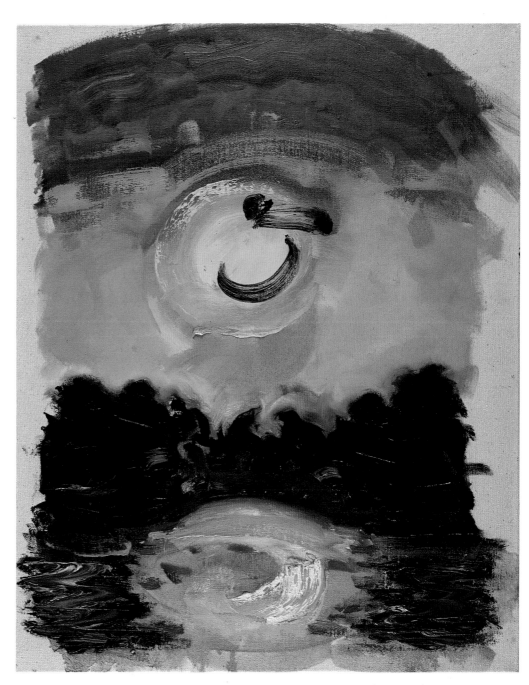

24 *July Sunrise, Orwell Estuary I* 1984 oil 53.3 × 43.2 cm (cat.5)

OPPOSITE

23 *Max and Me (In Praise of Smoking)* 1982 oil 195.6 × 96.5 cm (cat.3)
Birmingham City Art Gallery

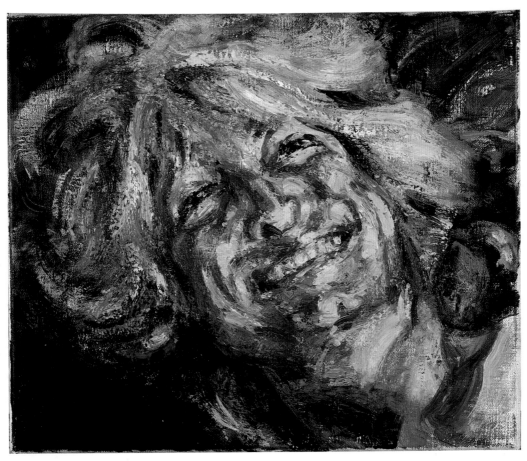

25 *Laughing Portrait* 1984 oil 25.4 × 30.5 cm (cat.6)

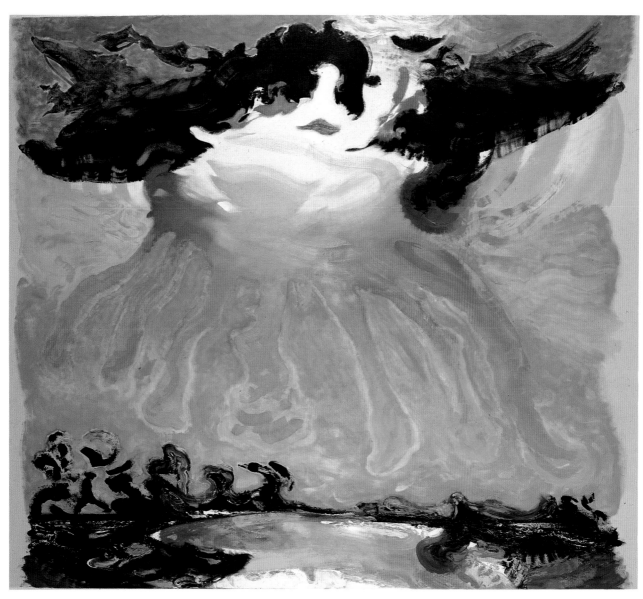

26 *Dragon Sunrise* 1986 oil 149.9 × 144.8 cm (cat.7)

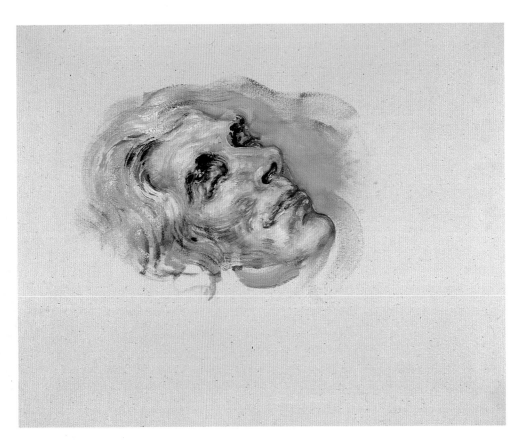

27 *My Mother Dead* 1988 oil 43.2 × 53.3 cm (cat.9)

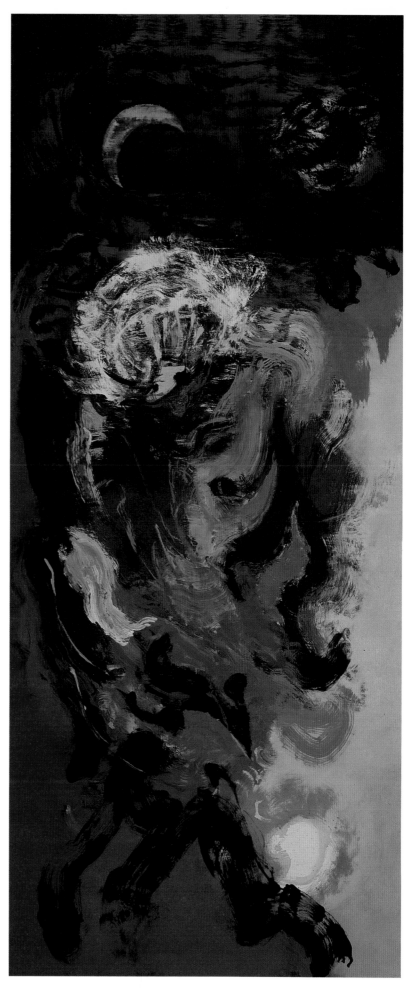

28 *Between Sun and Moon* 1990 oil 213.4 × 91.4cm (cat.13)

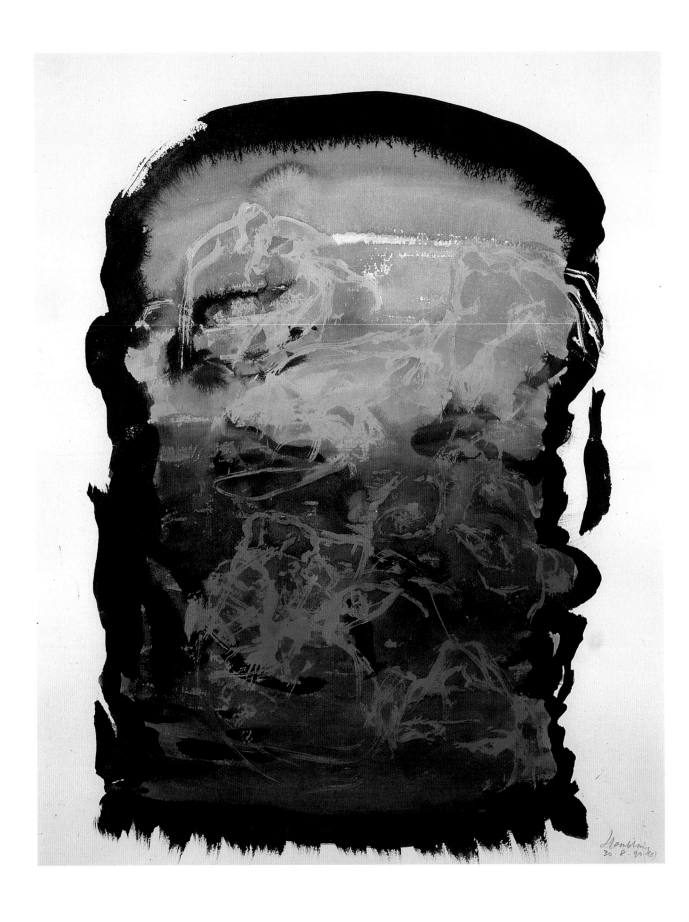

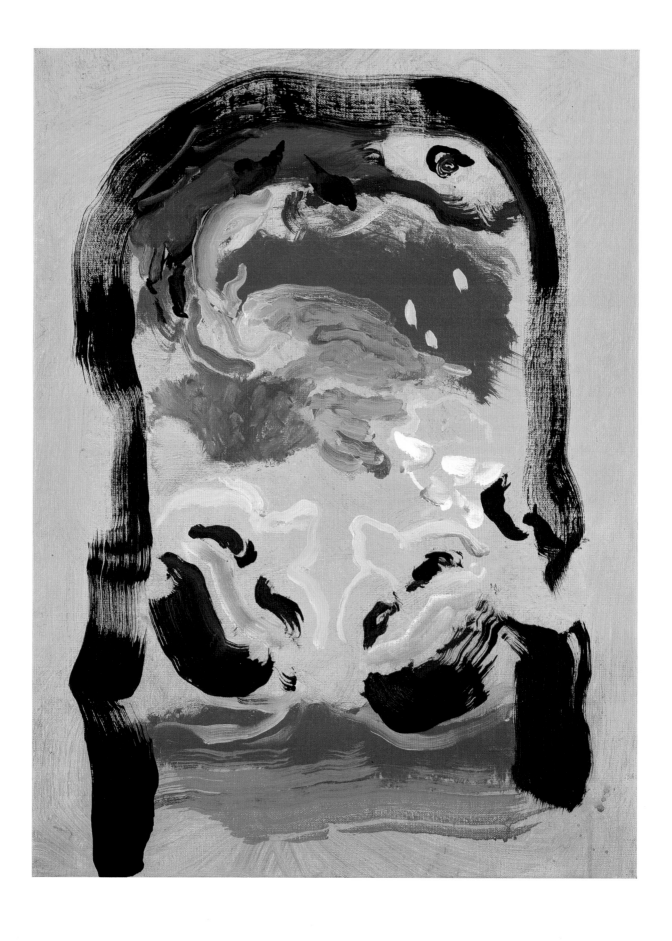

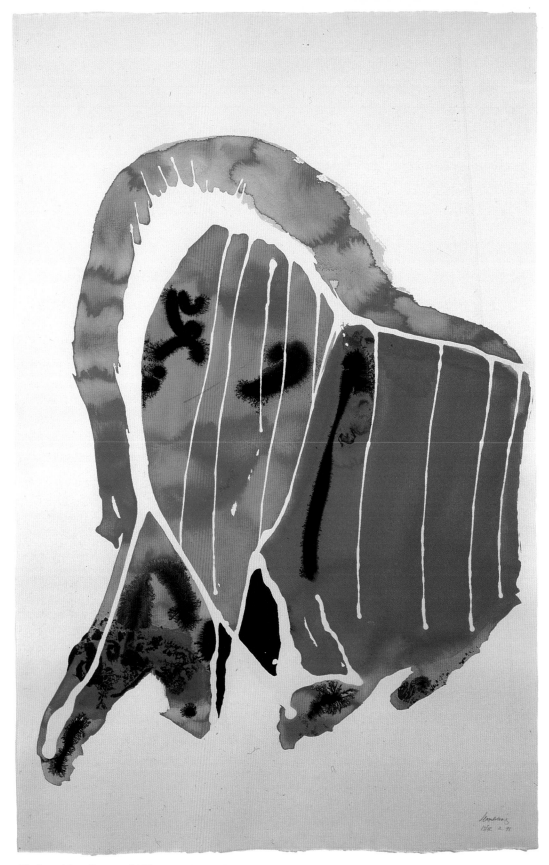

31 *Laughing Creature* 1991 watercolour/ink 101.6 × 63.5 cm (cat.35)

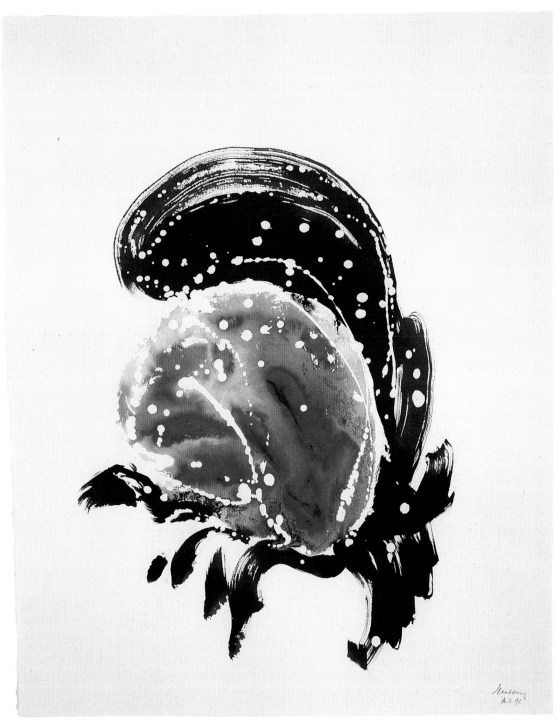

32 *All Souls' Laugh* 1991 watercolour/ink 61 × 48.3 cm (cat.36)

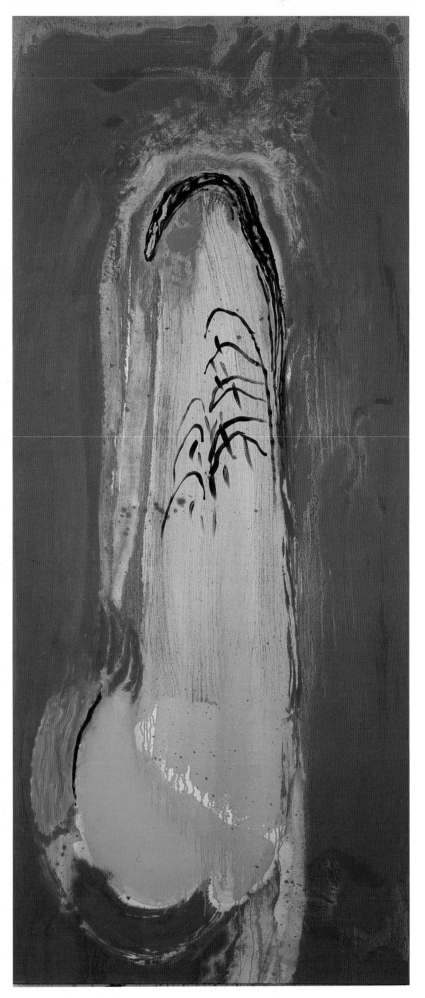

33 *Onion* 1991 oil 213.4 × 91.4 cm (cat.16)

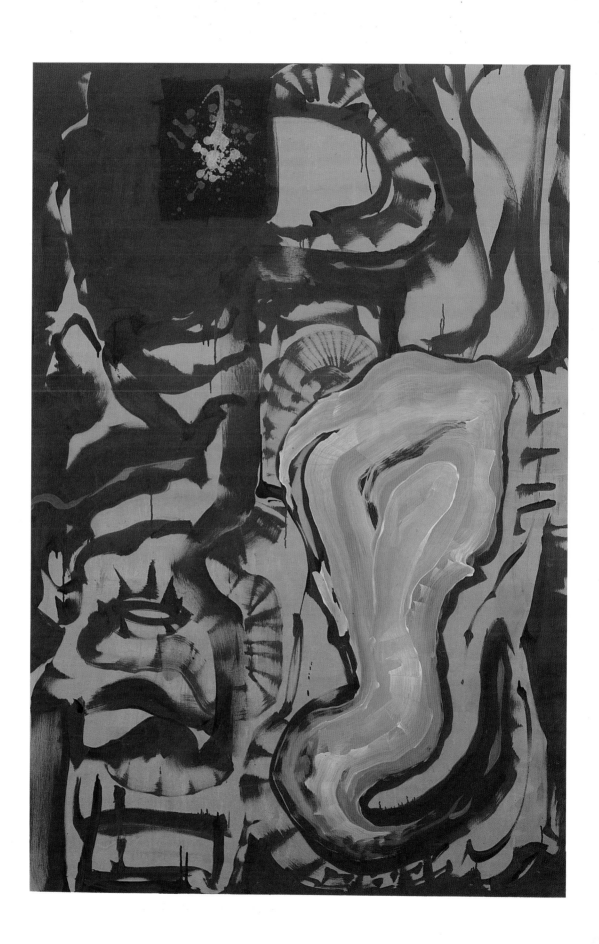

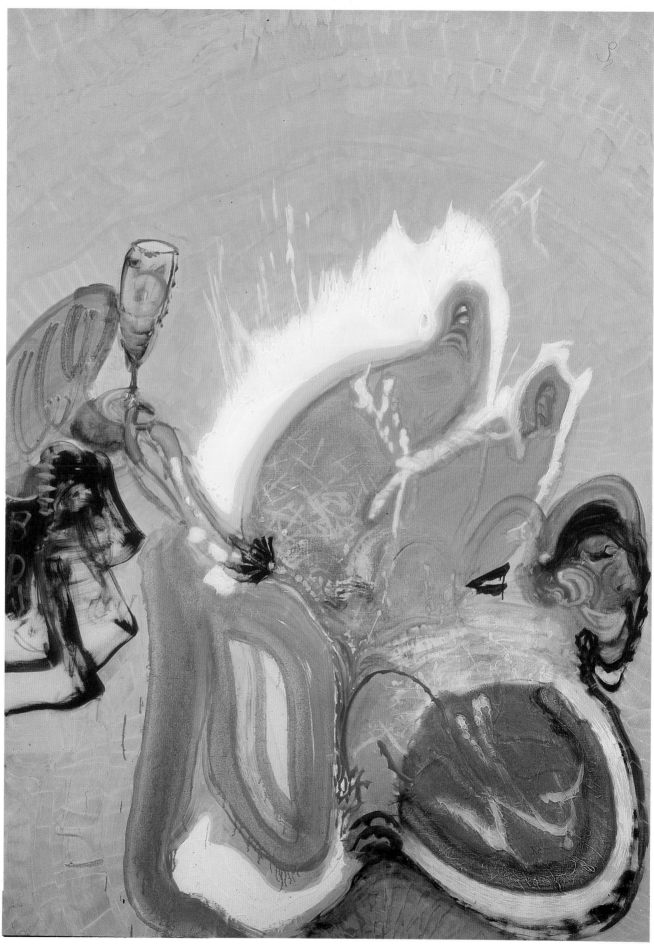

36 *Champagne Laugh* 1991 oil 213.4 × 152.4 cm (cat.22)

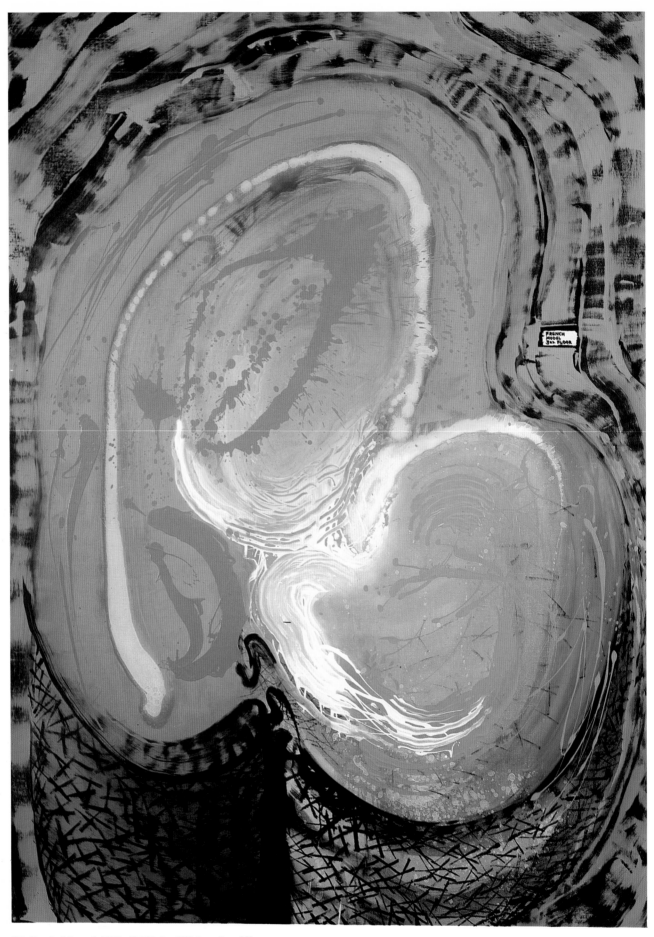

37 *Brothel Laugh* 1991 oil 213.4 × 152.4 cm (cat.23)

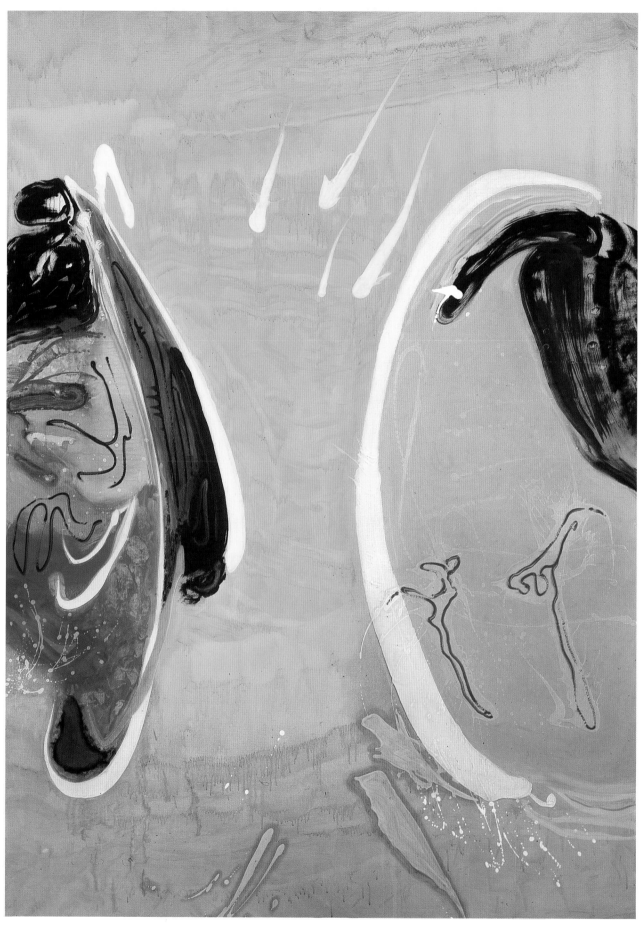

38 *Secret Laugh* 1991 oil 213.4 × 152.4 cm (cat.24)

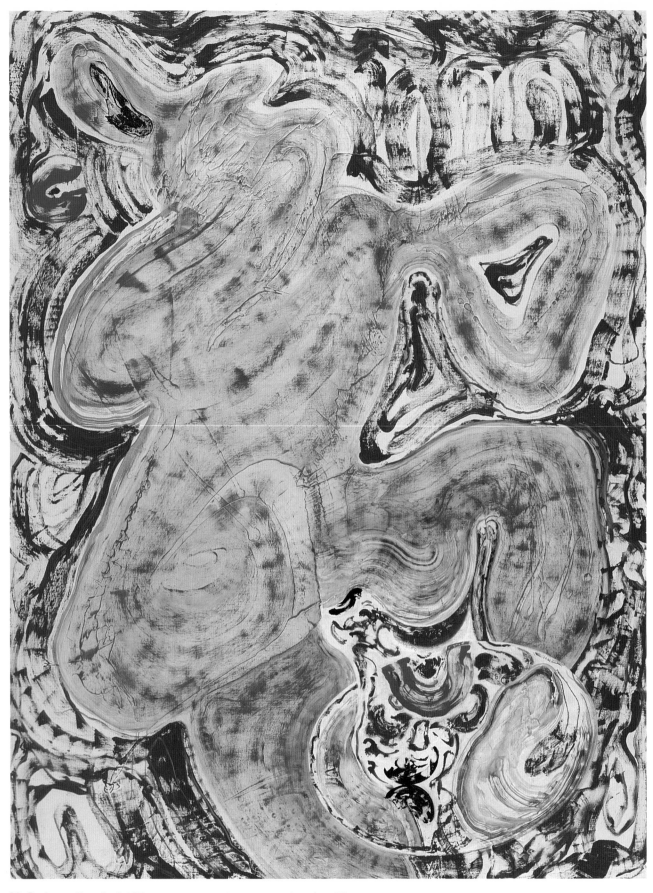

39 *Bathroom Laugh (Self-Portrait)* 1991-2 oil 243.8 × 182.9 cm (cat.25)

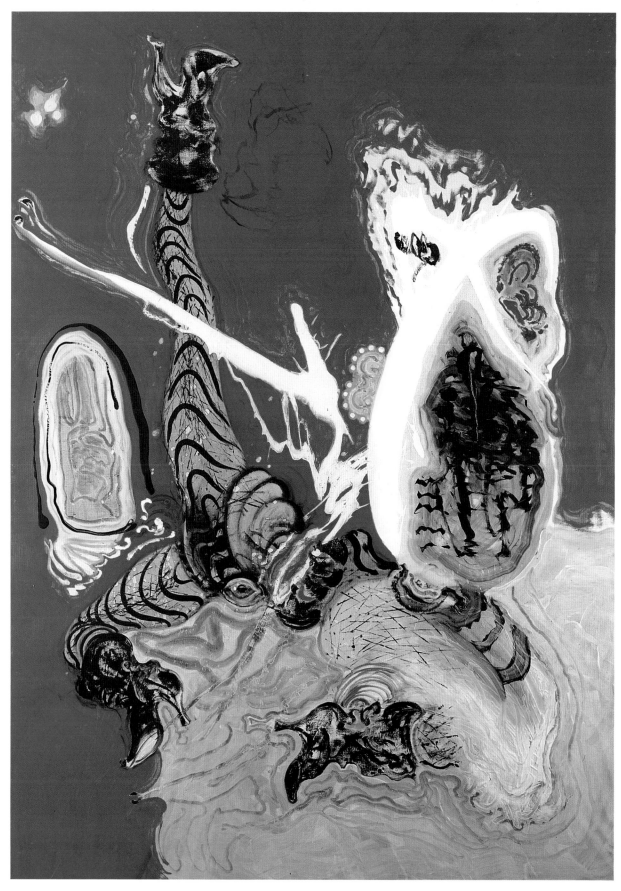

40 *Laugh Defying Death* 1992 oil 213.4 × 152.4 cm (cat.26)

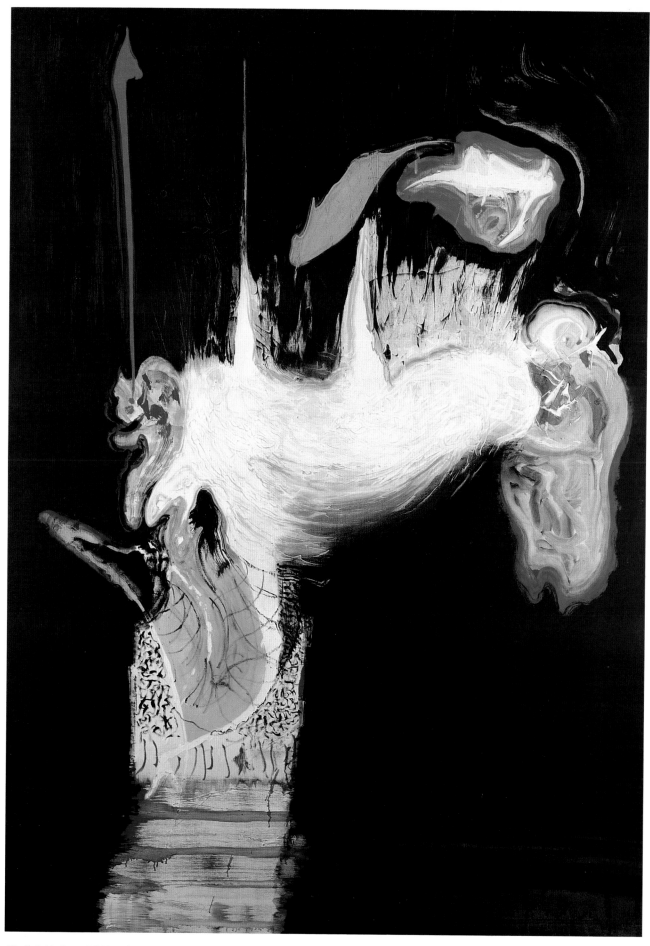

41 *Suicide Laugh* 1992 oil 213.4 × 152.4 cm (cat.27)

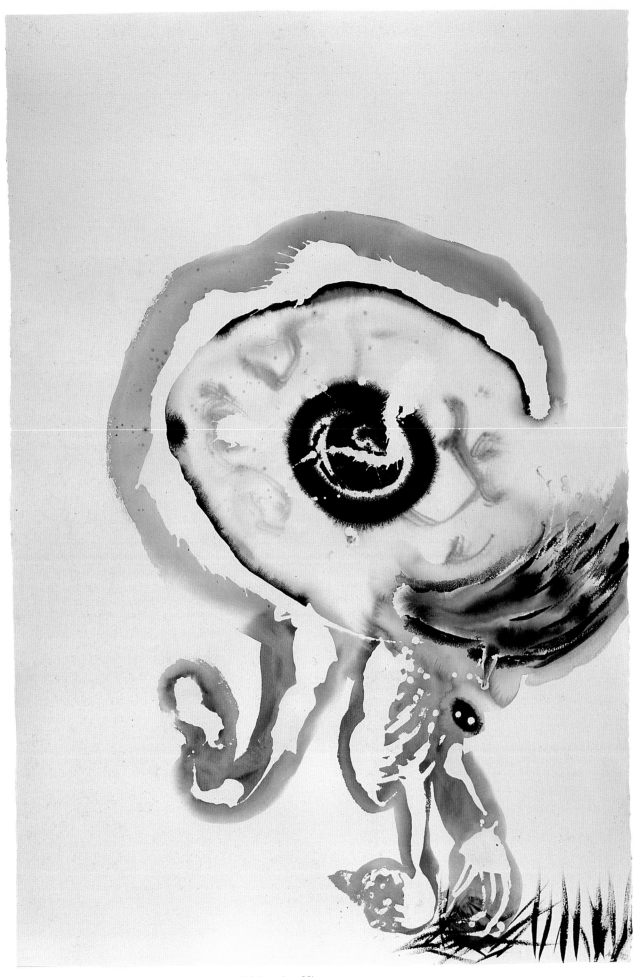

42 *Self-Portrait* 1992 watercolour/ink 153.7 × 101.6cm (cat.39)

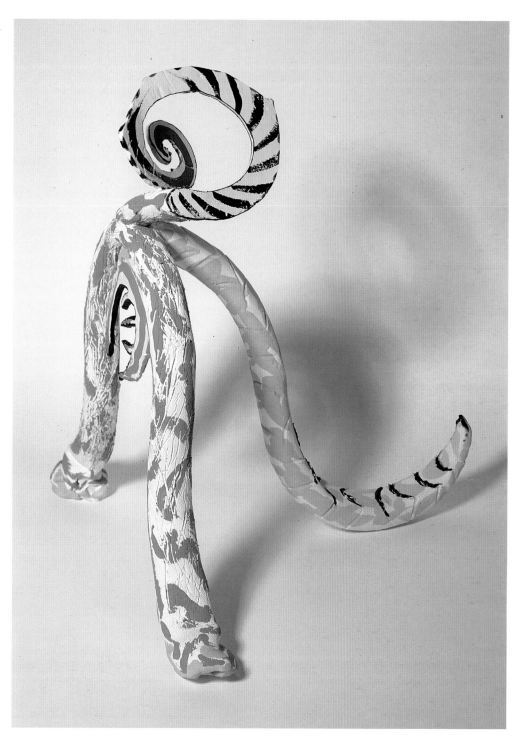

43 *Hermaphrodite Self-Portrait* 1993 high-fired clay with engobe
39.4 × 35.6 × 33 cm Victoria and Albert Museum

Chasing the Dragon

Here be not only dragons, but moons, suns, stars and planets supported by club-legged creatures arching over backwards, whose dangling heads survey their own tumescent organs, rearing serpents, arrested water, animate vegetation. Freaked and dappled with colour, with blues, reds, oranges and blacks, they at first suggest a disarming gaiety but closer examination corrects this reassuring impression. Their interests, one suspects, are almost certainly not the same as ours. They have their own priorities. They coil!

I first saw some of them a few weeks ago at the Royal College of Art where every Tuesday the painter Maggi Hambling works in the ceramics department learning to handle this new medium. In this she owes a great deal to the help and advice of Matt Groves, who has not only taught her the various technical processes involved, but has also shown remarkable empathy.

But what pointed Maggi in this direction? The CCA Gallery, London, exists for the most part on the sale of prints. About three times a year, however, Marian Stone approaches an established artist to propose they change their spots. It was suggested to Maggi that she might decorate some plates, an idea which held no appeal to her. Hambling, however, was intrigued at trying something new, and offered a counter proposal – three-dimensional objects in fired clay: and as the RCA has a policy of inviting certain artists to extend their skills, everything fell into place.

The challenge was timely. Maggi had come to the end of a series of very large paintings attempting to evoke the various manifestations of the human laugh. Many of these were among the best work she has done, and the last is a masterpiece. Even so, she was destroying more and more of them (less extravagant than the young Bacon, she paints over the rejected images rather than ripping them up) and, while drawing as diligently as ever, was clearly at a watershed. Every Tuesday for the last few months she has shut the door of the studio in Clapham and set out for South Kensington.

The first experiment was not encouraging; a kind of collapsed soufflé which she has kept as a self-deprecating joke, and it *is* comic. She is, however, nothing if not persistent and, with Matt's encouragement and practical assistance, her first alien life-forms were soon crawling out of the clay. They were, while recognisable, rather clumsy to begin with. It is interesting to trace their almost Darwinian development. What are their sources? There are echoes of the *Laugh* series but it is the earlier *Sunrise* period which is

more in evidence and indeed she has called the whole exhibition *Dragon Morning*. Another source is a particularly large and spontaneous watercolour [plate 42] which is among the few two-dimensional works in front of which her personages freeze like disturbed insects carrying all the heavens.

Maggi Hambling has always relied on hard and obsessively regular work and, at the same time, an open acceptance of chance and serendipity. They have not failed her here. Shortly after she had begun to find her way in this new medium, and had become especially fascinated by the image of the arched woman supporting the moon, she went to Egypt on a pre-booked holiday and there, painted on the ceiling of a tomb, was the Goddess Nut (pronounced Noot), a female counterpart of Atlas, but propping up the firmament. Egypt, however, didn't change her direction, it simply confirmed it. Indeed, in style there is a strange hint of China, lair of the dragon and of the calligraphic brushstroke. The only European works I was reminded of in any way were the painted sculptures and assemblages of Miró, but they are very distant cousins, alike only in their vitality and avoidance of whimsy.

I encountered Maggi's works for the second time in her studio, waiting for their plastic cases in which, rather reassuringly, given their uncertain temper, they are to be displayed. In the short period since I first saw them, they had bred alarmingly. Maggi was tentatively euphoric. I asked if she intended to continue experimenting in three dimensions. She thought so, but was very excited about getting back to painting. This year, apart from two commissioned portraits, she hadn't painted at all, only drawn, but that for her is like breathing. She has indeed just started on her first large oil of 1993. She usually paints big and this was no exception. I therefore asked her if her sculpture was likely to grow. She thought it possible, but if so would probably model in wax, which could be cast directly in bronze and then painted.

I suspect that painting will always remain her priority. She is in love with paint, its viscosity, its manipulation. She admits, though, that sculpture has taught her greater patience. 'You're forced to wait for as long as forty-eight hours,' she said, 'while the firing takes place.' The wait, however frustrating, was worth it.

GEORGE MELLY
This article first appeared in The Guardian *on 7 June 1993 on the occasion of the exhibition* Dragon Morning: Works in Clay *at the CCA Galleries, London*

Dimensions are given as height before width (or height before width before depth for works of sculpture) and centimetres before inches

OILS

1 [plate 22]
Mask 1972
50.8 × 40.6 (20 × 16)
Collection Andrew Logan

2 [plate 2]
Lett Laughing 1975-6
71 × 64.8 (28 × 25½)
Collection Mary Cookson

3 [plate 23]
Max and Me (In Praise of Smoking) 1982
195.6 × 96.5 (77 × 38)
Collection Birmingham City Art Gallery

4 [plate 5]
Portrait of the Ghost of Cedric Morris 1983
91.4 × 71 (36 × 28)
Collection the artist

5 [plate 24]
July Sunrise, Orwell Estuary I 1984
53.3 × 43.2 (21 × 17)
Collection Sir Michael Culme-Seymour

6 [plate 25]
Laughing Portrait 1984
25.4 × 30.5 (10 × 12)
Collection the artist

7 [plate 26]
Dragon Sunrise 1986
149.9 × 144.8 (59 × 57)
Collection the artist

8 [plate 7]
Dead Bull 1987
94 × 76.2 (37 × 30)
Collection Fiona Cunningham-Reid

9 [plate 27]
My Mother Dead 1988
43.2 × 53.3 (17 × 21)
Collection the artist

10
Drowning Sunset 1988
148.6 × 86.4 (58½ × 34)
Collection George Melly

11
August Sunrise 1989
213.4 × 91.4 (84 × 36)
Collection the artist / Bernard Jacobson Gallery

12 [plate 10]
Breaking the Moon 1989
243.8 × 121.9 (96 × 48)
Collection the artist / Bernard Jacobson Gallery

13 [plate 28]
Between Sun and Moon 1990
213.4 × 91.4 (84 × 36)
Collection the artist / Bernard Jacobson Gallery

14
August Night 1990
243.8 × 121.9 (96 × 48)
Collection the artist / Bernard Jacobson Gallery

15 [plate 30]
The Happy Dead 1990
53.3 × 43.2 (21 × 17)
Collection the artist

16 [plate 33]
Onion 1991
213.4 × 91.4 (84 × 36)
Collection the artist

17 [plate 34]
Christmas Laugh (In Memory of my Mother) 1991
182.9 × 121.9 (72 × 48)
Collection the artist

18
Spanish Laugh 1991
182.9 × 121.9 (72 × 48)
Collection the artist

19
Night Laugh 1991
213.4 × 152.4 (84 × 60)
Collection the artist

20 [plate 35]
Ghosts of Laughs 1991
213.4 × 152.4 (84 × 60)
Collection the artist

21 [plate 15]
Avebury Laugh 1991
243.8 × 182.9 (96 × 72)
Collection the artist

22 [plate 36]
Champagne Laugh 1991
213.4 × 152.4 (84 × 60)
Collection the artist

23 [plate 37]
Brothel Laugh 1991
213.4 × 152.4 (84 × 60)
Collection the artist

24 [plate 38]
Secret Laugh 1991
213.4 × 152.4 (84 × 60)
Collection the artist

25 [plate 39]
Bathroom Laugh (Self-Portrait) 1991-2
243.8 × 182.9 (96 × 72)
Collection the artist

26 [plate 40]
Laugh Defying Death 1992
213.4 × 152.4 (84 × 60)
Collection the artist

27 [plate 41]
Suicide Laugh 1992
213.4 × 152.4 (84 × 60)
Collection the artist

28 [plate 16]
Sprouting Person 1992
50.8 × 40.6 (20 × 16)
Collection the artist

WATERCOLOURS

29
The Happy Dead I 1990
Watercolour / ink, 61 × 48.3 (24 × 19)
Collection the artist

30
The Happy Dead II 1990
Watercolour / ink, 61 × 48.3 (24 × 19)
Collection the artist

31
The Happy Dead III 1990
Watercolour / ink, 61 × 48.3 (24 × 19)
Collection the artist

32
The Happy Dead IV 1990
Watercolour / ink, 61 × 48.3 (24 × 19)
Collection the artist

33
The Happy Dead V 1990
Watercolour / ink, 61 × 48.3 (24 × 19)
Collection the artist

34 [plate 29]
The Happy Dead VI 1990
Watercolour / ink, 61 × 48.3 (24 × 19)
Collection the artist

Biography

35 [plate 31]
Laughing Creature 1991
Watercolour/ink, 101.6 × 63.5 (40 × 25)
Collection the artist

36 [plate 32]
All Souls' Laugh 1991
Watercolour/ink, 61 × 48.3 (24 × 19)
Collection the artist

37
Night Laugh 1991
Watercolour/ink, 101.6 × 63.5 (40 × 25)
Collection the artist

38 [plate 13]
Interior Laugh 1991
Watercolour/ink, 101.6 × 63.5 (40 × 25)
Collection the artist

39 [plate 42]
Self-Portrait 1992
Watercolour/ink, 153.7 × 101.6 ($60\frac{1}{2}$ × 40)
Collection the artist

SCULPTURE IN HIGH FIRED CLAY WITH
ENGOBE (all 1993)

40
Sunrise With Hangover
16.5 × 29.2 × 19 ($6\frac{1}{2}$ × $11\frac{1}{2}$ × $7\frac{1}{2}$)
Collection the artist/CCA Galleries

41 [plate 19]
Advancing Sun
29.2 × 47 × 20.3 ($11\frac{1}{2}$ × $18\frac{1}{2}$ × 8)
Collection the artist

42 [plate 20]
Laughing Dragon
27.3 × 35.6 × 20.3 ($10\frac{3}{4}$ × 14 × 8)
Collection the artist/CCA Galleries

43
Bird Yawning
33 × 30.5 × 15.2 (13 × 12 × 6)
Collection Lady MacMillan

44
Serpent Bearing Star II
61 × 22.9 × 22.9 (24 × 9 × 9)
Collection the artist/CCA Galleries

45
Early Morning Swimmer
36.2 × 18.4 × 14.6 ($14\frac{1}{4}$ × $7\frac{1}{4}$ × $5\frac{3}{4}$)
Collection the artist/CCA Galleries

1945	Born in Suffolk

STUDIED

1960 onwards	With Lett Haines and Cedric Morris
1962-4	Ipswich School of Art
1964-7	Camberwell School of Art
1967-9	Slade School of Fine Art
1969	Boise Travel Award, New York
1977	Arts Council Award
1980-1	First Artist in Residence, National Gallery, London

EXHIBITIONS

1967	*Paintings and Drawings*, Hadleigh Gallery, Suffolk
1973	*Paintings and Drawings*, Morley Gallery, London
1977	*New Oil Paintings*, Warehouse Gallery, London
1981	*Drawings and Paintings on View*, National Gallery, London
1983	*Pictures of Max Wall*, National Portrait Gallery, London and tour
1987	*Maggi Hambling*, Serpentine Gallery, London
1988	*Maggi Hambling*, Richard Demarco Gallery, Edinburgh, Maclaurin Art Gallery, Ayr
	Moments of the Sun, Arnolfini Gallery, Bristol and tour
1990	*New Paintings 1989-90*, Bernard Jacobson Gallery, London
1991	*An Eye Through a Decade*, Yale Center for British Art, New Haven, Connecticut
1992	*The Jemma Series, Monotypes*, Bernard Jacobson Gallery, London
1993	*Dragon Morning, Works in Clay*, CCA Galleries, London
	Towards Laughter, Maggi Hambling, Northern Centre for Contemporary Art and tour

SELECTED GROUP EXHIBITIONS

1973	*Artists' Market*, Warehouse Gallery, London
1974	*Critic's Choice*, Tooth's Gallery, London
	British Painting, '74, Hayward Gallery, London
1976	*The Human Clay*, Hayward Gallery, London
1977	*Artists' Market*, Warehouse Gallery, London
1978	*6 British Artists*, British Council Drawing Exhibition, Yugoslavia
1979	*Narrative Paintings*, Arnolfini, Bristol and tour
	The British Art Show, Mappin Art Gallery, Sheffield and tour
1980	*British Art, 1940-80*, Hayward Gallery, London
1981	*The Subjective Eye*, Midland Group, Nottingham and tour
	13 British Artists, British Council Painting Exhibition, Germany
1982	*Private Views*, Arts Council Touring Exhibition
1983	*Pintura Britanic Contemporanea*, Museo Municipal, Madrid
	3 Decades of Artists, Royal Academy, London
	Britain Salutes New York, Marlborough Gallery, New York
1984	*The Hard Won Image*, Tate Gallery, London
1985	*A Singular Vision*, Royal Albert Memorial Museum, Exeter and tour
	In Their Circumstances, Usher Hall, Lincoln and tour
	Human Interest, 50 Years of British Art About People, Cornerhouse, Manchester
1986	*Visual Aid for Band Aid*, Royal Academy, London
	Artist and Model, Whitworth Art Gallery, Manchester
	In Close Up, National Portrait Gallery, London
1987	*The Self-Portrait*, Artsite, Bath and tour
1988	*Athena Art Awards*, Barbican, London
	Artists in National Parks, Victoria and Albert Museum, London and tour
1989	*Within These Shores*, A Selection of Works from the Chantrey Bequest 1883-1985, Sheffield City Art Galleries
	Salute to Turner, Thomas Agnew & Sons, London
1989-90	*Picturing People – British Figurative Art Since 1945*, British Council, Malaya, Hong Kong and Singapore
1990	*Nine Contemporary Painters*, City of Bristol Museum & Art Gallery
1991	*Modern Painters*, Manchester City Art Gallery
1992	*Eighty Years of Collecting, The Contemporary Art Society*, Hayward Gallery, London and tour
	Life into Paint: British Figurative Painting of the Twentieth Century, British Council, Israel Museum, Jerusalem
1993	*Images of Christ*, Northampton and St Paul's Cathedral, London
	Writing on the Wall, Tate Gallery, London

PUBLIC COLLECTIONS

Aldeburgh Foundation, Suffolk
All Souls' College, Oxford
Arts Council of Great Britain
Australian National Gallery, Canberra
Birmingham City Art Gallery
British Council
British Museum, London
Chelmsford and Essex Museum
Christchurch Mansion, Ipswich
Clare College, Cambridge
Contemporary Art Society
Eastern Arts Collection
Fondation du Musée de la Main, Lausanne
Greater London Council
Greene King Breweries, Suffolk
Greenwich Theatre, London
Gulbenkian Foundation, Lisbon
Haddo House, Aberdeenshire
Harlech Television, Bristol
Harris Museum and Art Gallery, Preston
Hartlebury Castle, Worcestershire
Hereford Cathedral
Imperial War Museum, London
Leicestershire Education Committee
The Minories, Colchester
Morley College, London
National Gallery, London
National Portrait Gallery, London
Norwich Castle Museum
Petworth House, West Sussex
Rockingham Castle, Northamptonshire
Royal Army Medical College, London
Rugby Collection
St Mary's Church, Hadleigh, Suffolk
St Mary's College, London
St Mary's Hospital, London
St Thomas' Hospital, London
Scottish National Gallery of Modern Art, Edinburgh
Scottish National Portrait Gallery, Edinburgh
Southampton Art Gallery
Swindon Museum and Art Gallery
Tate Gallery, London
Templeton College, Oxford
Unilever House, London
University College, London
Victoria and Albert Museum, London
Wakefield Art Gallery
Warwick University, Coventry
Whitworth Art Gallery, Manchester
William Morris School, London
Yale Center for British Art, New Haven, Connecticut

Bibliography

ARTICLES

Ackroyd, Peter, Television: 'Moving Pictures', *The Times*, 6 November 1984

Arnott, Christopher, 'The Opening Day Dodge', *The New Haven Advocate*, 19 September 1991

Bailey, Paul, 'Maggi Hambling Talks with Paul Bailey', *Modern Painters* vol.4 no.2, Autumn 1991

Beaumont, Mary Rose, 'Maggi and Max – Hambling and Wall', *Arts Review*, 4 March 1983; *Arts Review*, 9 October 1987; *Galleries*, October 1990

Beckett, Sister Wendy, 'Contemplative Art', *Catholic Herald*, 7 June 1991

Billen, Andrew, 'Gallery's Rogue', *Observer Magazine*, 7 October 1990

Bumpus, Judith, 'The Artist at Work: Maggi Hambling', *Art & Artists*, March 1983; 'In Celebration', *Art & Artists*, September 1985; 'Sir George Solti by Maggi Hambling', *Fortieth Aldeburgh Handbook*, June 1987

Burn, Guy, 'Prints', *Arts Review*, March 1992

Carey, Frances, 'Maggi Hambling's Monotypes', *Print Quarterly*, June 1992

Cooke, Lynne, 'Maggi Hambling at The National Portrait Gallery', *Artscribe* no.40, April 1989

Cooper, Emmanuel, *Time Out*, 16-23 June 1993

Cork, Richard, 'Off-the-Wall Obsession', *The Standard*, 17 March 1983; 'Dawn Patrols', *The Listener*, 5 November 1987

Feaver, William, 'Bring On the Clowns', *The Observer*, 20 March 1983

Feinstein, Elaine, 'A Profile of the Artist', *Modern Painters* vol.I no.2, Summer 1988

Fleishmann, Eric, 'Shift from Realism to Abstraction Traced in Exhibit of Hambling Art', *New Haven Register*, 22 September 1991

Fuller, Peter, 'London Maggi Hambling', *Burlington Magazine*, November 1987

Gale, Ian, 'Excursions into the Third Dimension', *The Independent*, 25 June 1993

Garlake, Margaret, *Art Monthly*, April 1983

Gleadell, Colin, 'Tour de Force', *The Hill*, November 1987

Halcrow, Margo, 'Artist Captures Character of a Clown Prince', *Glasgow Herald*, 29 March 1983

Hall, Charles, 'Maggi Hambling', *Arts Review*, 2 November 1990

Hambling, Maggi, 'Studies and Shadows' (script of Radio 4 talk), *The Listener*, 26 March 1981; 'Velasquez: the Reality of Paint', *Modern Painters* vol.2 no.4, Winter 1989-90; 'Still Brandishing the Brush' (interview with Harry Hambling), *The Oldie*, 2 April 1993

Jamieson, Maggie, 'Maggi Hambling at Bernard Jacobson Gallery', *City Limits*, 25 October 1990

Januszczak, Waldemar, 'A Very Private View', *The Guardian*, 9 March 1983

Kemp, John, *Modern Painters* vol.III no.3, September 1990

Kent, Sarah, *Time Out*, 29 October 1987; *Time Out*, 31 October 1990

Lambirth, Andrew, 'Maggi Hambling – Making It Real', *Artist's and Illustrator's Magazine* issue 22, July 1988; 'From Sunrise to Moonrise', *Royal Academy Magazine* no.28, Autumn 1990; 'Portrait as Conversation (Maggi Hambling with Andrew Lambirth)', *Modern Painters*, Winter 1992; 'Mixed Media Profile', *Artist's and Illustrator's Magazine*, May 1993

Loppert, Susan, 'Maggi Hambling', *Galleries*, March 1992

Mackeson, Vyvyan, 'A Brush with Mick McGahey', *Sunday Times Scotland*, 9 October 1988

Melly, George, 'Serpentine Gallery – Maggi Hambling', *Artline* vol.III no.8, 1987; 'Places in the Sun', *The Guardian*, 16 July 1988; 'Chasing the Dragon', *The Guardian*, 7 June 1993

Messenger, Chrissie, 'On the Wall', *Artline* no.5, March 1983

Packer, William, 'The National Gallery's First Artist in Residence', *Financial Times*, 7 October 1980; 'Max Wall', *Financial Times*, 5 March 1983; 'Of Sacred Beasts and Bullish Things', *Financial Times*, 20 October 1987; *Financial Times*, 20 October 1990

Richards, Margaret, 'Max as Seen by Maggi', *Tribune*, 25 March 1983

Scobie, Ilka, 'Illuminating Laughter', *Cover* (New York), September 1991

Spalding, Frances, 'Maggi Hambling at the National Gallery', *Arts Review*, 27 February 1981

Vaizey, Marina, 'Maggi Hambling / Jane Joseph', *Financial Times*, 25 May 1973

Watkins, Jonathan, 'Maggi Hambling', *Art Monthly*, October 1987

Yale University Weekly Bulletin and Calendar, 'British Art Center Hosts First US Exhibit of Maggi Hambling's Works', 2-9 September 1991

CATALOGUES

Barker, Barry, Introduction to *Moments of the Sun*, Arnolfini Gallery, Bristol, 1988

Cork, Richard, *New Paintings 1989-1990*, Bernard Jacobson Gallery, London, 1990

Gibson, Robin, *Introduction to Max Wall – Paintings by Maggi Hambling*, National Portrait Gallery, London, 1983

Gooding, Mel and Melly, George, *Maggi Hambling – An Eye Through a Decade*, Yale Center for British Art, 1991

Hyman, James, *Life into Paint: British Figurative Painting of the Twentieth Century*, Israel Museum, Jerusalem, 1992

Hyman, Timothy, *In Their Circumstances*, Usher Gallery, Lincoln, June 1985

Lambirth, Andrew, *Nine Contemporary Painters*, City of Bristol Museum & Art Gallery, 1990

Lynton, Norbert, *Human Interest*, Cornerhouse, Manchester, October 1985; *Picturing People – British Figurative Art Since 1945*, British Council, 1989

Melly, George and Collins, Judith, *Towards Laughter: Maggi Hambling*, Northern Centre for Contemporary Art / Lund Humphries, 1993

Morphet, Richard, *The Hard-Won Image*, Tate Gallery, 1984

Tate Gallery, *Illustrated Catalogue of Acquisitions, 1982-84*, 1985; *Illustrated Catalogue of Acquisitions, 1984-86*, 1987; *Illustrated Biennial Report, 1986-88*, 1989; *Illustrated Biennial Report, 1990-92*, 1993

Warman, Alister, *13 British Artists*, Neue Galerie Aachen, 1981

Warner, Marina (and others), *Maggi Hambling*, Serpentine Gallery, 1987

TELEVISION

Maggi and Max, Hambling and Wall, Channel 4, 27 March 1983, directed by Judy Marle

Looking into Paintings: Portraits, Channel 4, 27 November 1985, Malachite Productions Ltd

Folio, Anglia Television, March 1988, directed by Michael Edwards

Making their Mark: Six Artists on Drawing, BBC2, 6 August 1990, directed by Dick Foster

Portrait Painting, Without Walls, Channel 4, 1992